THE FIRST WORLD WAR AT SEA IN PHOTOGRAPHS

1918

PHIL CARRADICE

AMBERLEY

First published 2015

Amberley Publishing
The Hill, Stroud
Gloucestershire, GL5 4EP

www.amberley-books.com

British Library Cataloguing in Publication Data.
A catalogue record for this book is available from the British Library.

ISBN 978 1 4456 2250 7 (print)
ISBN 978 1 4456 2273 6 (ebook)

Typesetting and Origination by Amberley Publishing.
Printed in Great Britain.

Contents

Introduction

1918 was destined to be the last year of the war, but as January dawned an end to hostilities was very far from anyone's mind. The U-boat menace was at its height; the British blockade of Germany was causing near-starvation; the great battlefleets of Britain and Germany still lurked, silent and menacing, in their home ports. There was every reason to suppose the war would continue for many months or even years to come.

As ever – or so it seemed to the men of the Royal Navy – the New Year began badly. A German destroyer raid on Yarmouth took place on 14 January, the enemy ships fleeing back across the North Sea before the defenders could react. It was followed by the loss of the submarine tender or depot ship *Hazard* on the 28th of the month. This time, the disaster was not as a result of enemy action but simply a collision in the English Channel.

In the Mediterranean the German battlecruiser *Goeben*, operating under the Turkish flag since the early days of the war and re-named *Sultan Selim*, was in action once more. On 20 January she sank the monitor *Raglan*, along with a smaller monitor, the M28, off Imbros. There was some limited relief for the British, as in the same operation the *Breslau*, the *Goeben's* consort on her 1914 run through the Mediterranean to find safety in Constantinople – the *Medilli* as she now was – struck a mine and sank.

Further British losses came at the end of the month when two of the new K Class submarines were sunk during a fleet exercise off May Island in the Firth of Forth. No German vessels were involved but two other K-boats were damaged in what was ironically called the Battle of May Island. As one pundit later said, the K Class submarines had 'the speed of a destroyer but the turning circle of a battleship'.

A number of significant events took place during 1918. They were the lynch-pin on which the naval war in that last year of conflict swung and depended:

On 1 April the Royal Naval Air Service and the Royal Flying Corps were amalgamated to form the Royal Air Force.

St George's Day, 23 April, saw an attack on Zeebrugge in an attempt to block the U-boats' access to the sea. A further blockading action at Ostend took place on 10 May.

An expeditionary force was landed at Murmansk on 23 June, the aim being to assist the White Russians in their battle against the Bolsheviks.

On 30 October an armistice was signed with Turkey, on board the battleship *Agamemnon*.

The final Armistice between the Allied forces and Germany was signed on 11 November in a railway carriage in the forest at Compiègne.

On 21 November the German High Seas Fleet arrived in the Firth of Forth on their way to internment in Scapa Flow. The German ships arrived in Scapa two days later.

The significance of the formation of the RAF was immense. If the war had shown one thing, it was the simple fact that air power was going to be the vital element in any future conflict between nations. The men and machines of both the RNAS and the RFC had performed heroically but they now required a single, dominant and united leadership that could dictate strategy as well as tactics. By welding both services into the new Royal Air Force, that was exactly what emerged.

The Zeebrugge attack on St George's Day was directly related to the British fear of the German U-boats. It was clear to everyone that the submarine threat had not been entirely negated by the recently implemented convoy system. Over 300,000 tons of Allied shipping was still being sent to the bottom of the sea each month, sometimes more: in March 1918 alone, the figure was as high as 340,000 tons.

The Admiralty was convinced that the U-boat base at Zeebrugge was full of submarines and small coastal craft that, as well as preying on Allied merchant shipping, might also lead a breakout into the English Channel. In those vital straits between Dover and Calais, loaded troop transports were regularly ploughing their way. And, of course, there was always the lurking threat of the German High Seas Fleet. Should those battleships and battlecruisers ever come out, the Zeebrugge force would be used to sweep the Channel and support the capital ships.

A number of German destroyer raids in the early part of the year convinced planners at the Admiralty that something would have to be done about the 'Zeebrugge pocket'. The German strength was never as great as the Admiralty thought, but Vice Admiral Roger Keyes came up with a plan that might just work. Instead of sinking the U-boats and enemy destroyers, Keyes suggested, why not put blockships across the canals that led from Zeebrugge and Ostend and just seal the Germans in? His plan was accepted.

The raid took place on 23 April, the action scheduled to boost British morale at a time when the Army was suffering major setbacks in France. Three obsolete cruisers, loaded with cement, scuttled themselves at the mouth of the Bruges canal. This was not totally effective as the Germans simply dredged out part of the flanking banks in order for submarines to pass by the sunken craft.

Diversionary attacks by the cruiser *Vindictive* and two C Class submarines that blew up part of the viaduct that ran out to the mole took place simultaneously. All of the British vessels came under consistent fire from the German shore batteries.

It was a brief but bitter and brutal encounter as the German defences were well-organised and efficient. The *Vindictive* and her supporting craft came under heavy fire, and 214 sailors and marines were killed. Many more were wounded and several taken prisoner. In an action that lasted just over an hour, eight Victoria Crosses were won.

An attack on Ostend was carried out at the same time as the Zeebrugge raid. The two blockships, *Sirius* and *Brilliant*, ran aground because of false marker buoys and their crews had to be taken off by motorboats. A second attempt was made on 9 May; this time the *Vindictive* was sunk across the channel. Only after the war was it realised that the Bruges–Ostend Canal was far too shallow for submarines to use.

The raids were something like the curate's egg – successful in parts. The Zeebrugge raid, in particular, did actually manage to seal in several U-boats, vessels that took no further part in the war. A secondary element of the operation, the sowing of over 70,000 mines between the Orkney Islands and the Norwegian coast, probably caused more discomfort and disaster to the U-boat crews. It effectively made the U-boat route to the Atlantic a very hazardous journey indeed.

The Russian Revolution of November 1917 had effectively taken the Russians out of the war, a withdrawal that was made official by the Treaty of Brest-Litovsk in March 1918. The Bolshevik Revolution was not without opposition, however, and soon the White Russian forces – troops that had remained loyal to the Czar and his regime – were engaged in bitter conflict with what had now become the Russian government. It was a costly and destructive civil war that was fought without quarter or respite by either side.

The Russian withdrawal caused consternation on the part of the Allies. Germany had, since the outbreak of the conflict, been forced to fight on two fronts. Now, this draining and demanding element of the war was suddenly over, and thousands of German troops, previously engaged in holding back the Russian hordes, were available to fight in the west. It was, therefore, inevitable that the Allies would quickly latch on to the civil war in Russia and seek to extend and prolong it for their own ends.

Allied involvement was, initially, to help the Czechoslovak Legion re-establish an Eastern Front. Lack of public support for the campaign, which dragged on long after the First World War ended, eventually forced the Allies to withdraw from Russia in 1920. To begin with, however, British naval forces were operating around the Murmansk and Archangel areas from 7 March 1918.

American and Canadian troops were also involved in the operations against 'the Reds' while the expanding Japanese empire was given a major boost when Japan's army planned and executed an invasion of Siberia. A British Expeditionary Force was landed at Murmansk by the destroyers *Syren* and *Penelope* at the end of June.

Meanwhile, out in the Atlantic, in the English Channel and in the North Sea, the naval war continued, as brutal and as bloodthirsty as ever. U-boats still claimed victims but it was the British blockade of Germany that was now the most effective weapon of war. There was, quite literally, starvation in many parts of Germany. To those who knew, it was obvious that things could not continue like this for very much longer.

Turkey, her empire in the Middle East rapidly disappearing by the day, finally sued for peace and an armistice was signed on board the battleship *Agamemnon* on 30 October. Three days later, Austria-Hungary also agreed to an armistice. Germany held out a little longer but a mutiny on board the ships of the High Seas Fleet, by sailors protesting against a proposed final 'suicide sortie' against the British, convinced the authorities that the war was lost.

On 8 November, in a railway carriage in the Forest of Compiègne, Marshal Foch, Admiral Wemyss and other dignitaries met with representatives of the German government to thrash out the terms of the Armistice. There was little to say and no real decision to be made – Germany would cease fighting on all fronts. With riots breaking

out all over the country, the Kaiser had no alternative. He approved the terms of the Armistice and promptly abdicated. The war was over.

It had been a long and brutal four years. The Royal Navy had suffered many grievous losses, both in ships and men, but the Senior Service and its sailors had grown immeasurably. When the Armistice was signed, RN manpower (and womanpower too, as the WRNS had grown rapidly since Dame Katherine Furse had been appointed Director of the Women's Royal Naval Service in November 1917) was 37,636 officers and 400,975 enlisted personnel. Ship strength stood at sixty-one battleships, nine battlecruisers, thirty cruisers, ninety light cruisers and 466 destroyers. There were also 147 submarines and a number of lighter and auxiliary craft such as trawlers, drifters and monitors.

War losses amounted to thirteen battleships, three battlecruisers (all three of them sunk at Jutland), twenty-five cruisers, sixty-seven destroyers and fifty-four submarines. There had also been many losses among armed merchant cruisers, escort sloops, minesweepers and coastal monitors.

The war might have ended but it was not yet time for everyone finally to go home. In the final month of 1918, an Allied occupation force finally swept, without opposition, into Germany and secured three important bridgeheads over the Rhine – the British at Cologne, the French at Mainz and the Americans at Coblenz. A flotilla of fast motor boats, ideal for operations on the river, was an important part of the British garrison.

The British occupation of Cologne lasted until 1926, although French and Belgian forces remained in situ much longer. The Americans pulled out their troops in 1924.

As part of the terms of the Armistice, Germany had to hand over her U-boat fleet. While many submarine crews promptly scuttled their vessels rather than consign them to the enemy, many did not, and the first twenty U-boats from the once-mighty German submarine fleet were handed over to the British at Harwich on 19 November.

There was worse to come. On 21 November the High Seas Fleet – eleven battleships, five battlecruisers and many smaller craft – arrived in the Firth of Forth en route to captivity at Scapa Flow. As Admiral Beatty promptly remarked, 'Didn't I tell you they'd come out?'

Internment of the German Fleet – the ships sailing into Scapa behind the light cruiser *Cardiff* – began on 23 November.

The trouble was, having finally got their hands on the High Seas Fleet, nobody at the Admiralty knew what to do with it. Consequently, the ships simply lay at their moorings, quietly rusting away, for the next seven months. The German sailors, desperate to get home to their families and loved ones, were forced to remain on board.

It was inevitable that something had to happen. On 21 June 1919 German flags rose to the mastheads of over seventy of the captive vessels, which soon began to settle on the mud of Scapa Flow. The German crews had scuttled their vessels. This expression of disgust and unhappiness annoyed the British government but it had little real effect, either on the Treaty of Versailles or on relations between Britain and Germany.

Salvaging the sunken vessels began soon enough. The operations continued unabated until the beginning of the Second World War and now the final remains of the sunken High Seas Fleet offer an interesting exploration site for amateur divers. Perhaps that is an appropriate end for the Kaiser's navy, a force that had been instrumental in bringing the world to war in 1914.

January

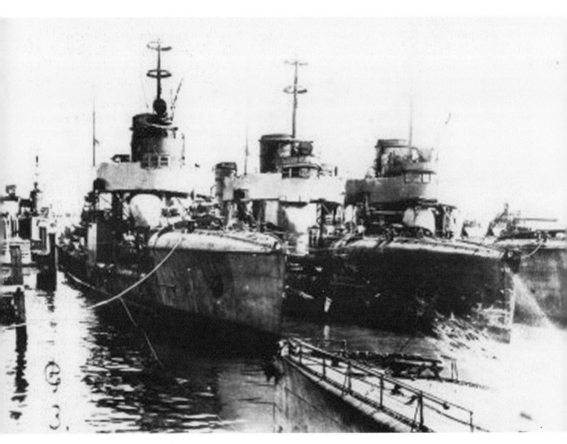

A German destroyer raid on Yarmouth was launched on 14 January, showing that the sea war was certainly not yet over. This shows German V Class destroyers, fast and powerful vessels despite their small size.

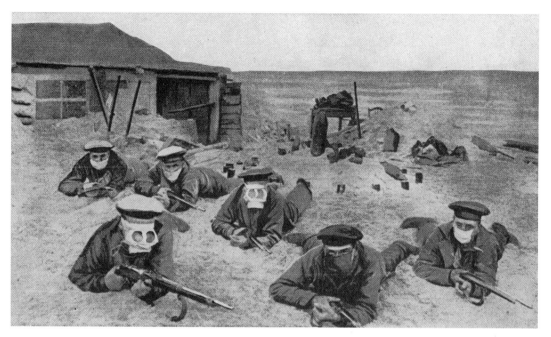

While the German fleet remained in port, the sailors could not be allowed to remain idle. This photograph shows sailors of the German fleet taking part in rifle practice ashore, some of them wearing gas masks.

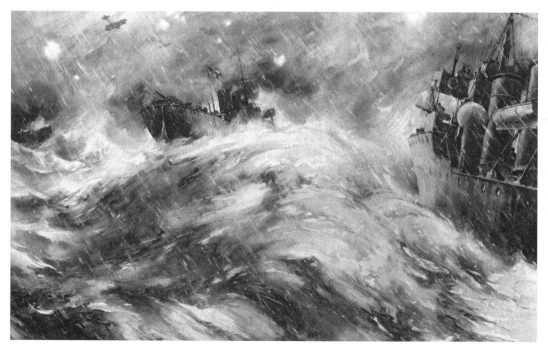

Whatever the weather, the war goes on. This painting shows British destroyers and a seaplane in action during a snow storm.

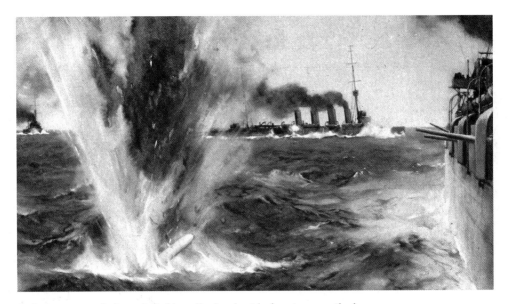

A German torpedo is exploded by a 'lucky shot' before it can strike home.

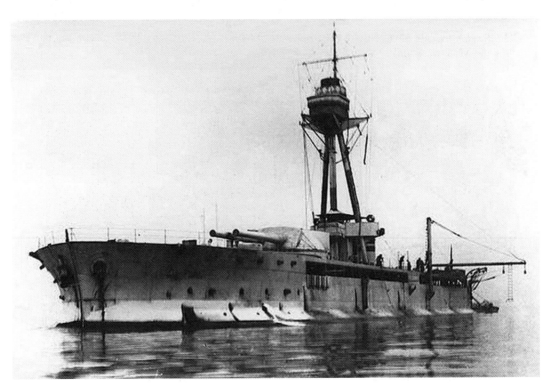

On 20 January the monitor *Raglan* was surprised and sunk while at anchor off Imbros by the *Goeben*, called *Yavuz Sultan Selim* since being handed over to the Turkish navy at the beginning of the war. The Battle of Imbros did not last long, coastal monitors not being designed for ship-to-ship combat.

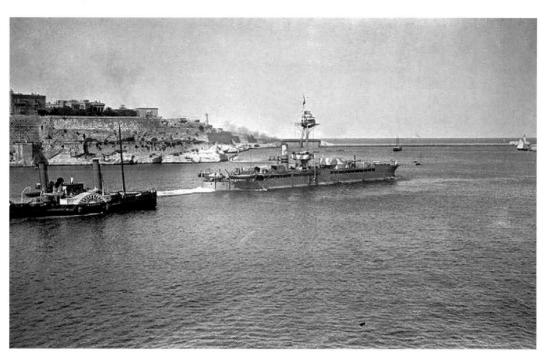

The *Raglan* leaving harbour. In the brief Battle of Imbros, both she and her companion, the monitor M28, were sunk.

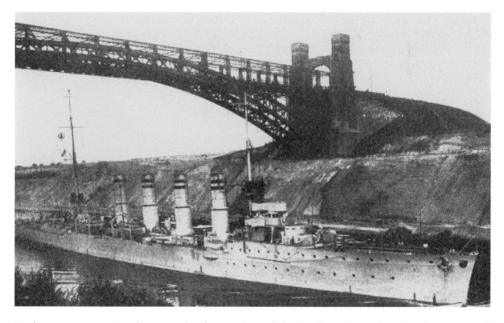

In the same operation that saw the destruction of the *Raglan*, the cruiser *Breslau*, renamed *Midilli* by the Turks, hit five mines while en route to attack the British battleship *Agamemnon*. She was run ashore and beached but, even so, over 300 of her crew were killed. This earlier view shows the *Breslau* in the Kiel Canal.

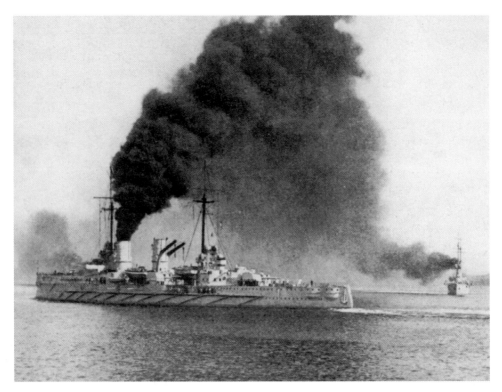

The battlecruiser *Goeben* getting up steam – the *Breslau* is waiting behind her.

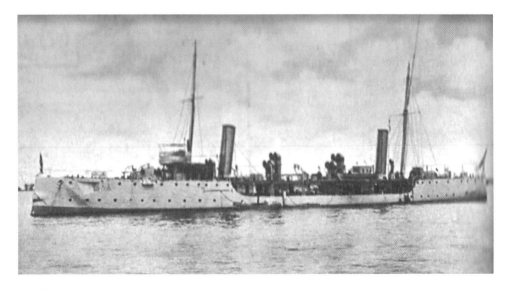

The *Hazard* was launched at Pembroke Dockyard in 1894 as a Dryad Class torpedo gunboat, but was converted into a submarine depot ship, one of the first in the Royal Navy, in 1901. In 1912 she rammed and sank one of her own submarines and was then herself lost in a collision on 28 January 1918, when she was rammed by the hospital ship *Western Australia* while operating in the Channel.

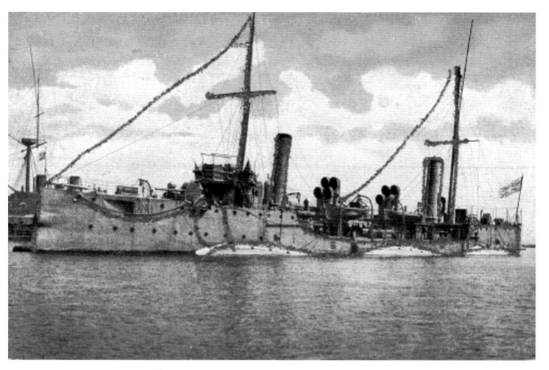

The *Hazard* was small and with a low freeboard, not really suitable for working as a submarine depot ship. Yet in the early days of submarine warfare, people at the Admiralty knew very little about what was required – it was a case of trial and error.

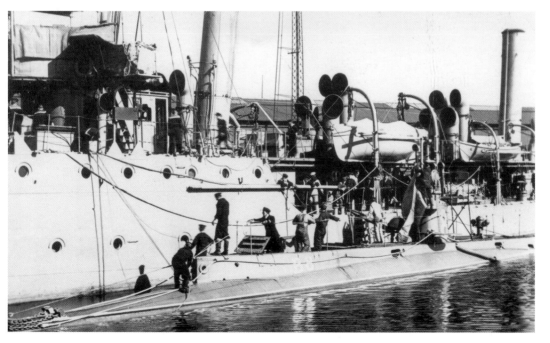

The depot ship *Hazard* is shown here with a small, early submarine alongside taking on stores.

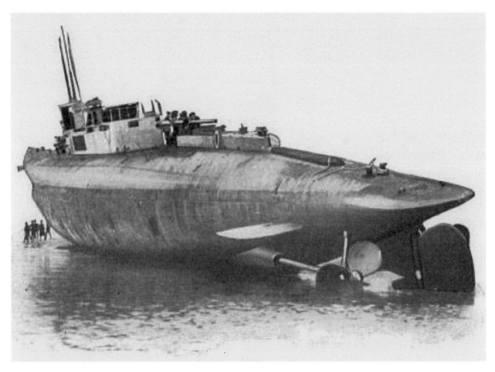

The submarine K4, wrecked and beached after being rammed by surface vessels during a fleet exercise in the Firth of Forth. Her sister ship K17 was also sunk and several more K-boats damaged in a bizarre series of accidents, known – somewhat ironically as no enemy ships and no offensive action were involved – as the Battle of May Island.

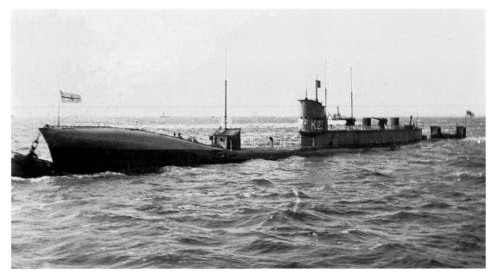

The submarine K22, badly damaged in the Battle of May Island when she was rammed by the battlecruiser *Inflexible*. The accidents showed serious design flaws in the K Class submarines, not least poor bridge or conning tower facilities.

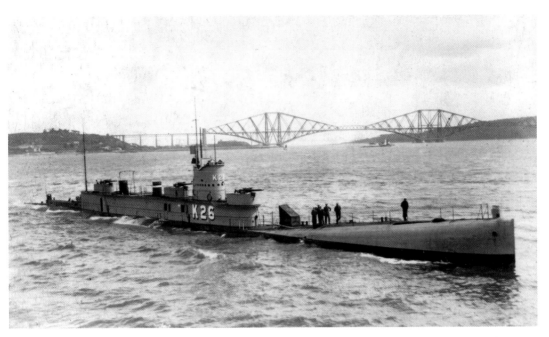

The K26, shown here off Rosyth in the Firth of Forth. Like all of the K Class submarines, her surface speed was incredibly high but she had the turning circle of a battleship.

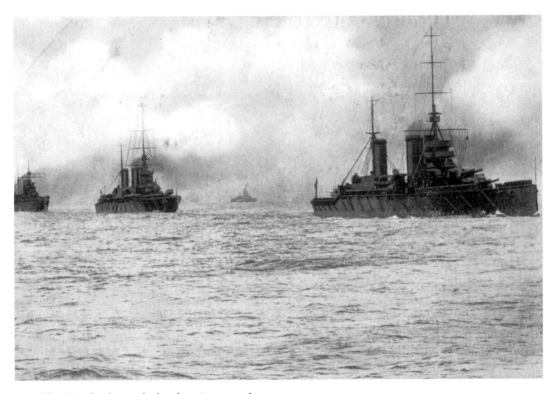

The *Lion* leads out the battlecruiser squadrons.

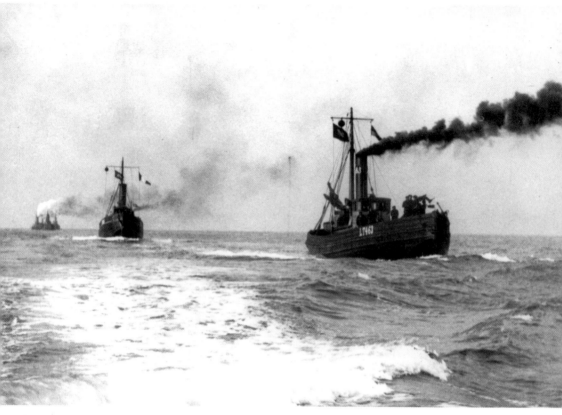

Drifters and trawlers from the Dover Patrol set out on a sortie to sweep mines at the mouth of the English Channel. The glory of the Dover Patrol might have lain with its fast destroyers but the trawlers and drifters that kept the sea lanes clear of mines carried out an invaluable role.

February

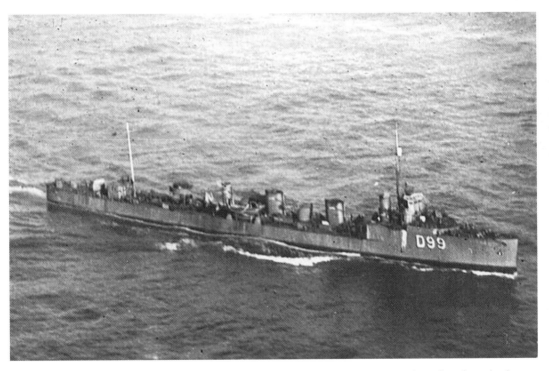

The destroyer *Zubian* – a composite warship made up of the destroyers *Zulu* and *Nubian*, both damaged beyond repair in 1916 – sank the UC50 on 4 February 1918.

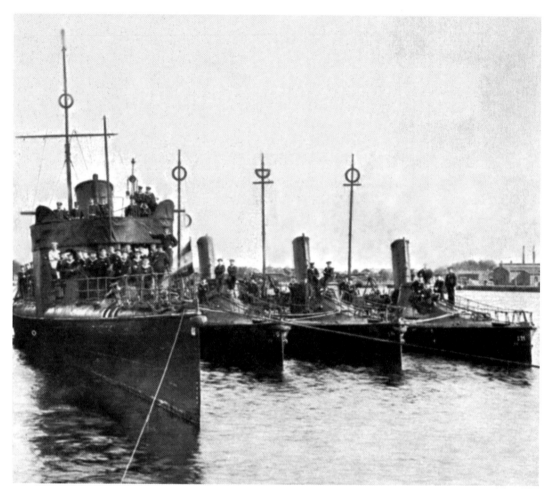

On 15 February, a destroyer and torpedo boat raid on British ships and installations in and along the Dover Straits showed the German intentions for the year – an offensive and aggressive series of actions in complete contrast to the immobility of the High Seas Fleet.

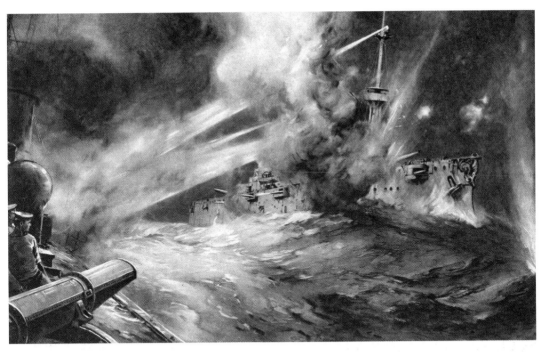

A destroyer action in the North Sea – an artist's impression that gives a good and graphic indication of what such a 'dogfight' would have been like.

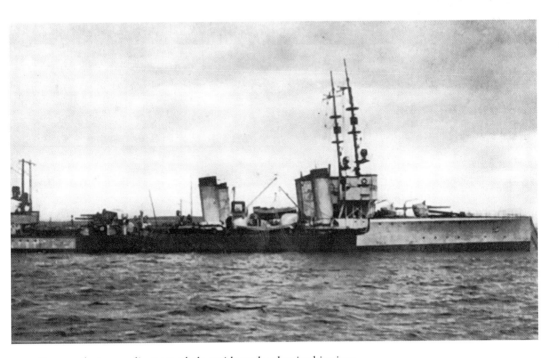

German destroyers lie moored alongside each other in this view.

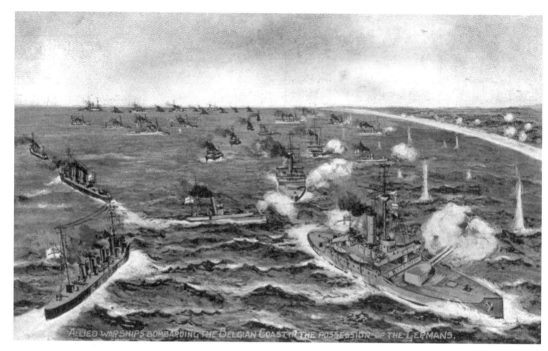

An artist's impression of British ships bombarding German emplacements on the Belgian coast – a rather romantic view of the operation, which, in reality, would have been conducted from much further out at sea.

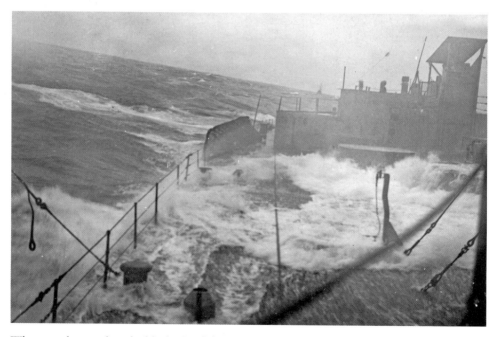

Whatever the weather, the blockade of the German coast continued with no respite, either for the Germans or for the men of the Royal Navy who had to enforce it.

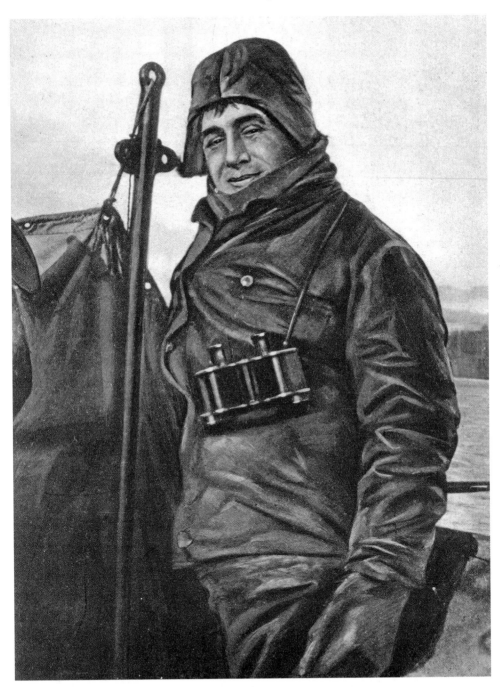

Max Horton, submarine ace, who served mainly in the Baltic.

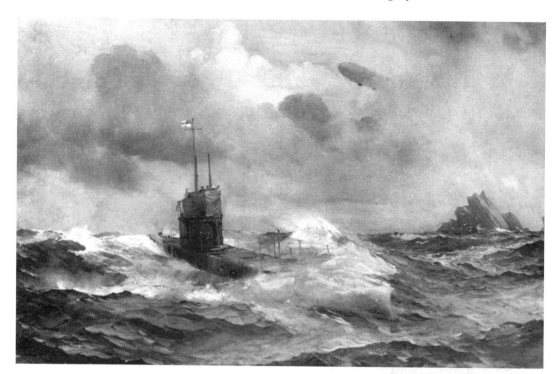

A British submarine endures stormy conditions in the Baltic while a Zeppelin glides serenely overhead.

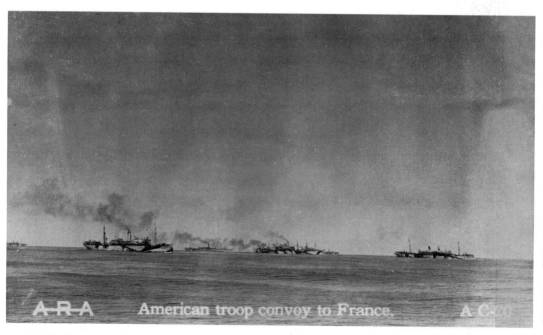

By the beginning of 1918 American troops were arriving in Europe in large numbers. This shows an American troop convoy, ships now 'dazzle painted', on its way to France.

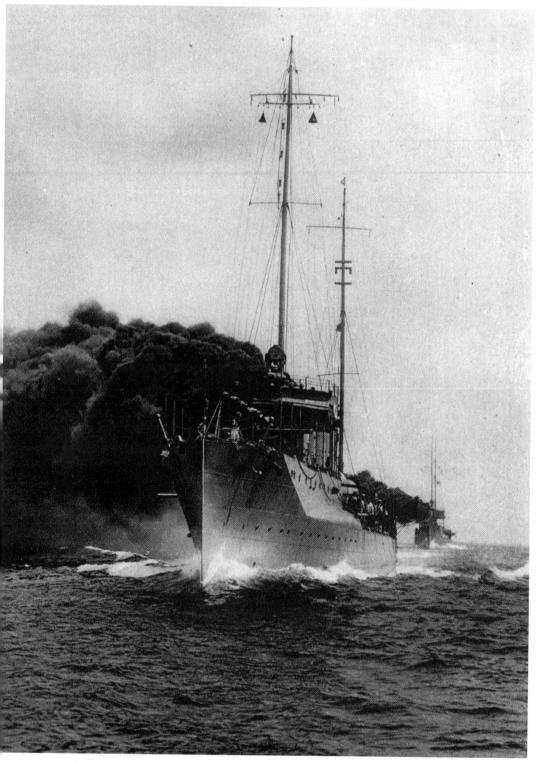

Two US Navy destroyers, USS *Benham* and USS *Parker*, making full speed ahead.

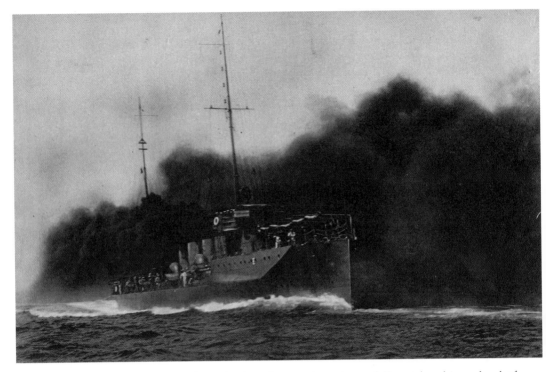

Another view of the USS *Benham* chasing after a submarine at full speed and in a cloud of black smoke.

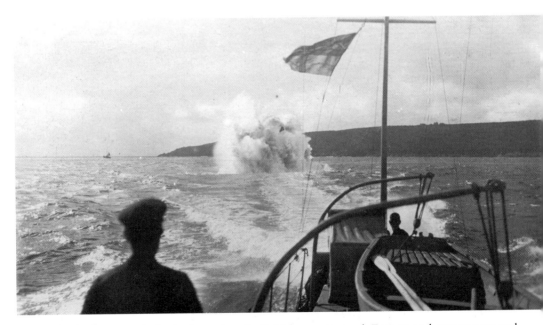

A depth charge explodes in the wake of a British escort vessel. Escorts and convoys proved highly successful in defeating the U-boat menace, despite the fears and scepticism of many people at the Admiralty.

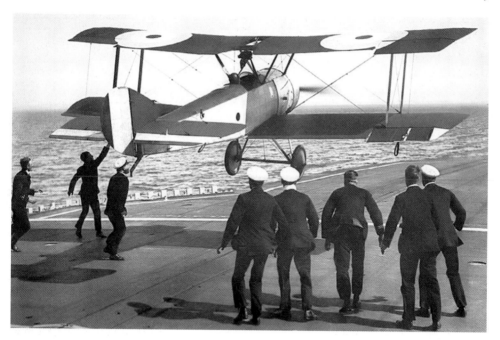

Experiments with aircraft landing and taking off from moving ships continued as the year went on, eager flyers happily following in the footsteps of Squadron Commander Dunning, who only the year before had taken off from the *Furious* – the first man to take off from and land on a moving ship. This shows Dunning in the process of landing his Sopwith Pup on the deck of the ship.

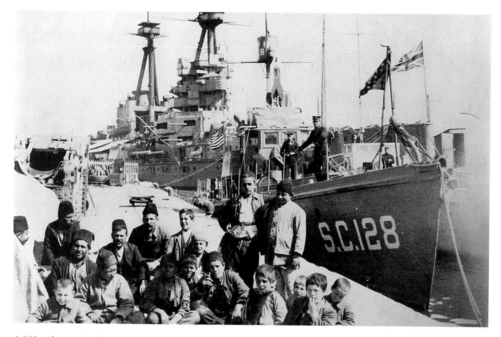

A US submarine chaser, one of many vessels sent across the Atlantic to help in the fight, is shown here in the waters off Salonika.

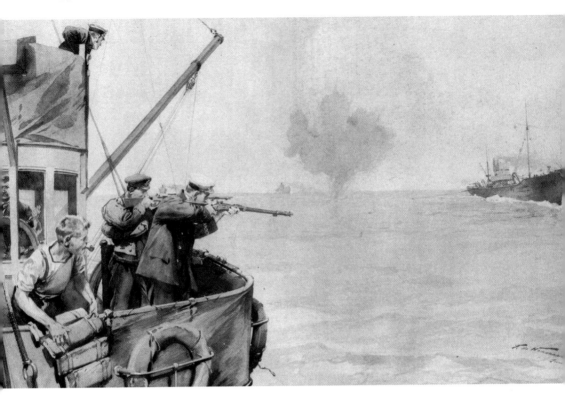

A mine has been cut loose by a sweeping trawler and is now bobbing, loose, on the surface. Sailors attempt to destroy it by rifle fire.

March

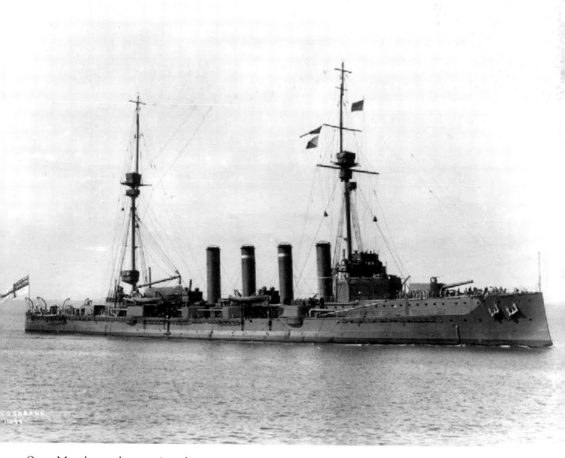

On 7 March naval operations began against Russian Bolshevik positions in Murmansk and Archangel. The cruiser *Cochrane* was one of several vessels involved, blockading the coast and destroying Russian supply vessels.

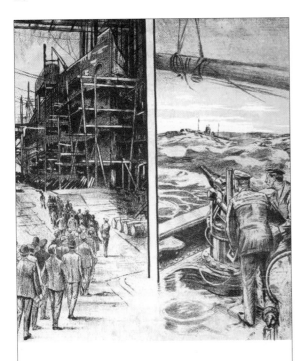

A propaganda postcard from 1918 emphasising the importance of the men behind the guns, without whom nothing would have been achieved.

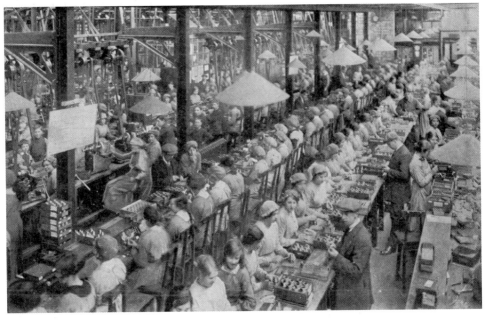

Male and female workers assembling shell fuses in a munitions factory.

On 6 March, Ensign E. F. Childs of the American navy was killed when the submarine H5 was rammed and sunk by a British merchant ship, the SS *Retherglen*. Childs was the first American submarine casualty of the war. He had been posted to the H5 in order to gain experience. This photograph was taken from the bridge of H5 shortly before the disaster.

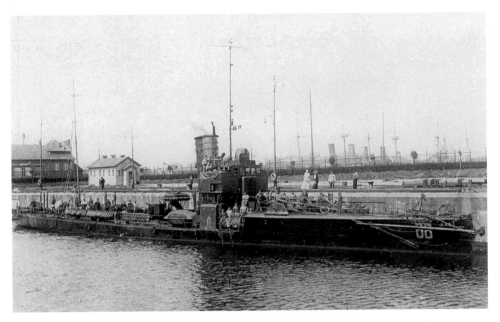

This photograph shows a German A Class destroyer, one of several vessels that fought an action with ships of the Dover Patrol off Dunkirk on 21 March. Eighteen German destroyers were involved, the A7 and A19 being sunk by the ships of the Royal Navy in the running fight.

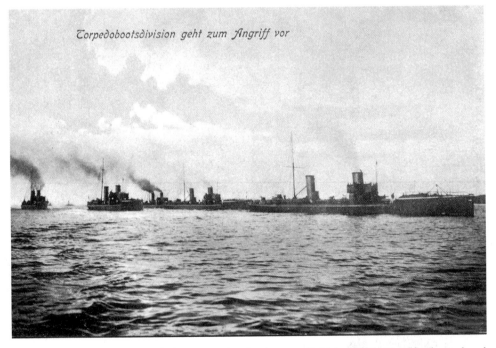

Torpedobootsdivision geht zum Angriff vor

German destroyers and torpedo boats remained a threat to British shipping in the Channel and North Sea right to the end of the war. The frenetic series of actions were in complete contrast to the immobility of the German High Seas Fleet.

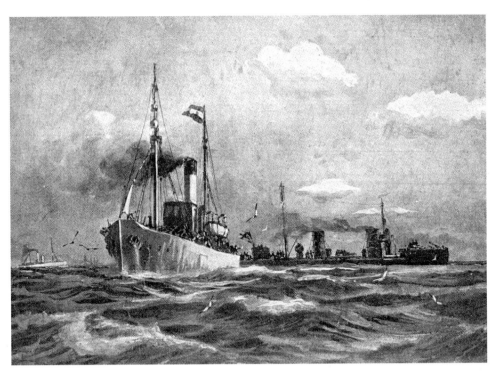

German torpedo boats are shown here in the process of stopping neutral shipping in the North Sea.

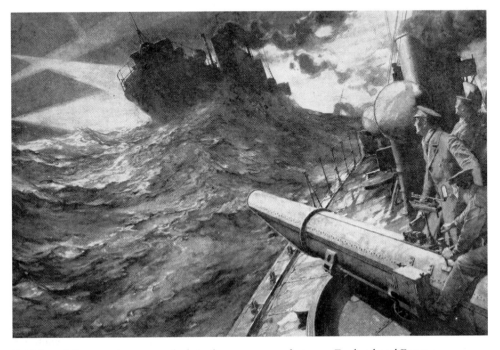

British and German destroyers clash in the narrow seas between England and Europe.

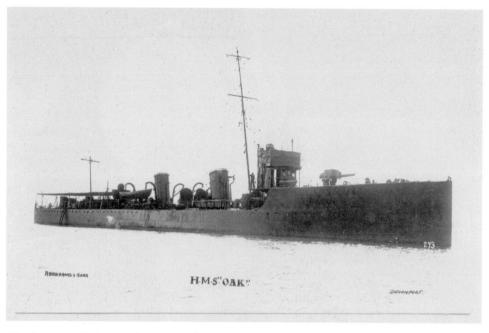

The destroyer *Oak*, one of many small vessels that made up units such as the Dover Patrol and the Harwich force.

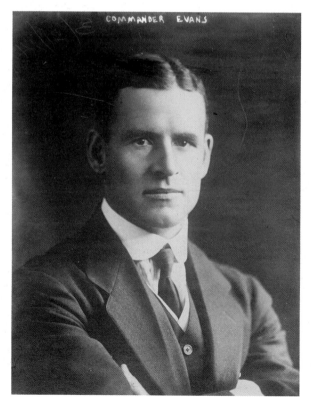

The activities of the Dover Patrol provided the British press with a golden opportunity to find 'heroes'. One of them was Teddy Evans, otherwise known as Evans of the Broke. He had been a member of Scott's expedition to Antarctica in 1912 and got to within 150 miles of the Pole before scurvy forced him back to base. As captain of the destroyer Broke, he achieved immortal fame in 1917 after ramming an enemy destroyer and fighting in hand-to-hand combat on the deck of the German vessel. He served with the Dover Patrol until the end of the war.

Night action in the North Sea, sailors suitably attired against the elements.

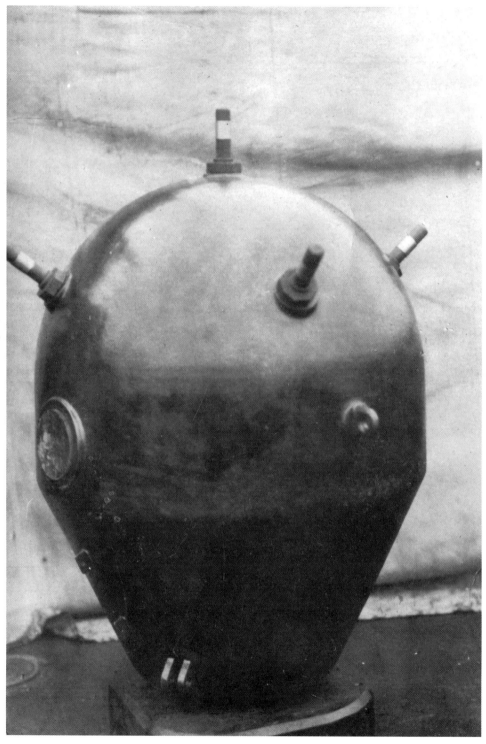

Mines, the silent killer of the seas, accounted for many merchant and naval ships of both sides during the war.

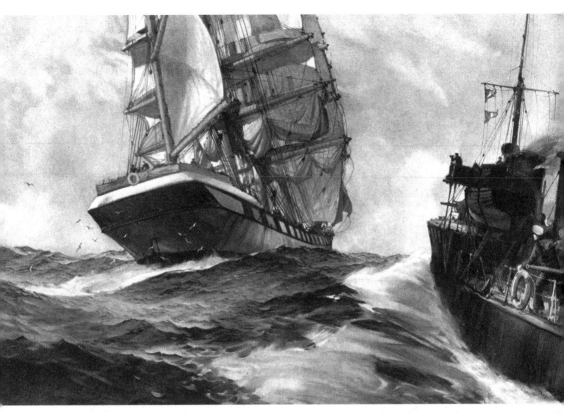

A British destroyer stops a neutral sailing ship, part of the continuing blockade of the German coast.

April

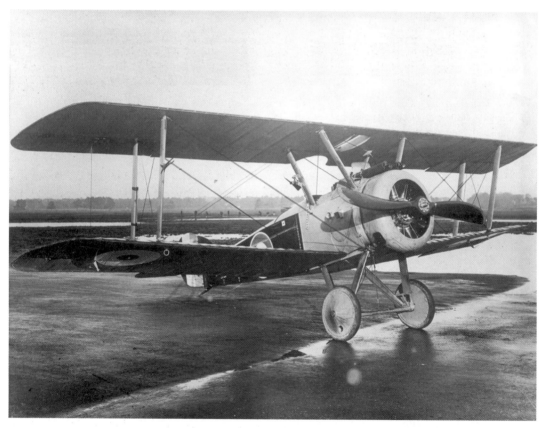

On 1 April, the Royal Naval Air Service and the Royal Flying Corps were amalgamated into the Royal Air Force. Nearly 3,000 aircraft and over 100 dirigibles passed out of the control of the Navy into the remit of the new service, along with some 60,000 pilots, observers and mechanics. Construction of airships and aircraft carriers remained in the hands of the Navy but it was 1924, when the Fleet Air Arm was formed, before the Navy began to fly aircraft once more.

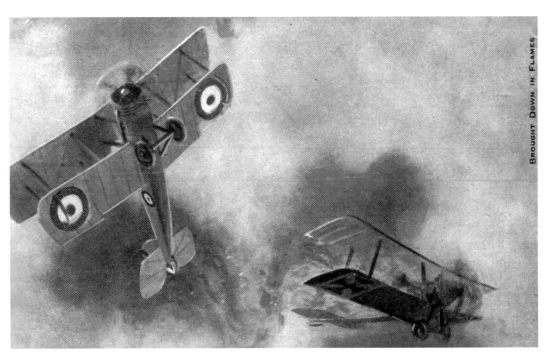

Aerial combat over the Western Front – RNAS pilots had played their part. From 1st April onwards they would be part of the new Royal Air Force.

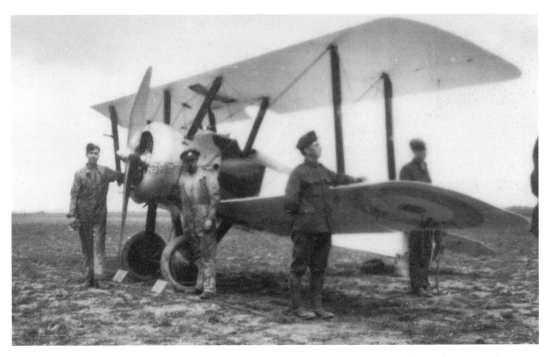

A Sopwith Camel fighter plane, one of the successes of the war in the air, is shown here, complete with ground crew, before taking off on patrol.

Vice Admiral Roger Keyes first proposed a scheme to block the German U-boats into their bases at Zeebrugge and Ostend in February 1918. There were many sceptics but, eventually, the idea was passed by the Admiralty. If nothing else, a raid on the U-boat bases would be a huge morale booster for the British public.

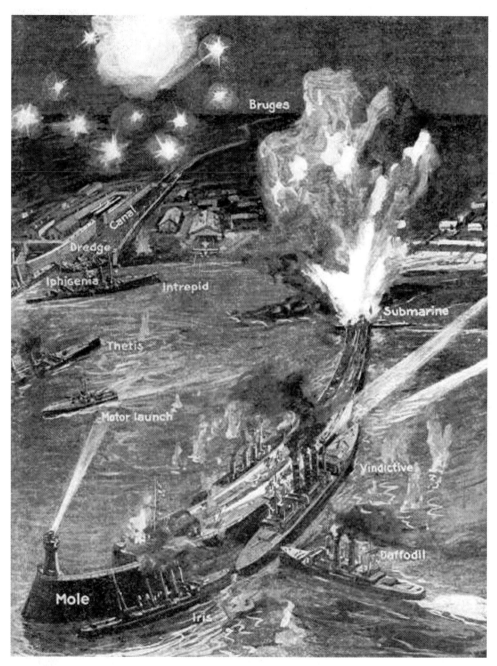

The raid on Zeebrugge took place on 23 April, St George's Day. The port was defended by artillery, machine guns, barbed wire and a garrison of over 1,000 men. The plan was for three obsolete cruisers, filled with cement, to sink themselves at the entrance to the canal that led to the submarine basin and so block the channel.

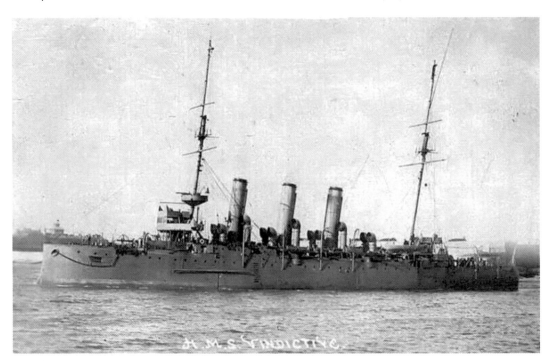

H.M.S. VINDICTIVE.

Faced by enormous firepower and a desperate enemy, some form of diversion was clearly required. This was provided by another old cruiser, the *Vindictive*. The plan was for her to land demolition parties on the mole – at nearly two miles long, it was then the longest mole or jetty in the world – where they would destroy the German guns. Motor launches and two ferry boats would accompany the *Vindictive*, along with two submarines filled with explosives, carrying more assault parties and providing support for the cruiser.

Fast patrol boats were used to support the marines involved in the Zeebrugge raid, and to take them off from the mole when the time came.

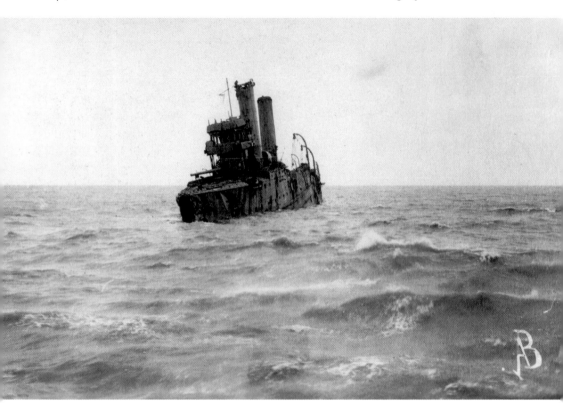

A change in the wind direction blew away much of *Vindictive*'s covering smoke screen and for the last 100 yards of her journey she was illuminated by searchlights and pummelled by enemy fire. Eventually she crashed into the mole and the landing parties clambered ashore. Damage to the ship was immense and casualties were heavy.

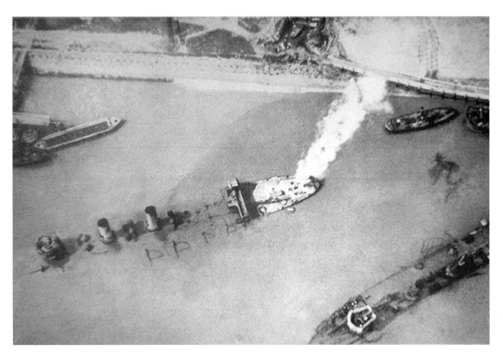

As this aerial view of the sunken blockships in the canal clearly shows, they did not totally close the channel but it was enough to cause serious problems for the U-boat commanders.

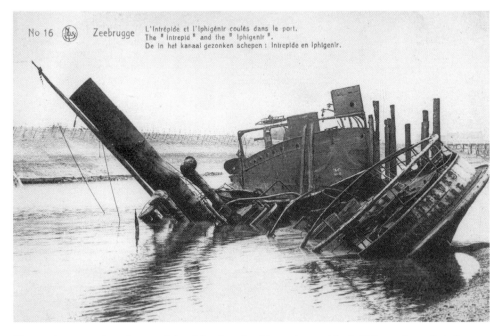

The sunken remains of two of the ships involved in trying to block U-boats into their base at Zeebrugge.

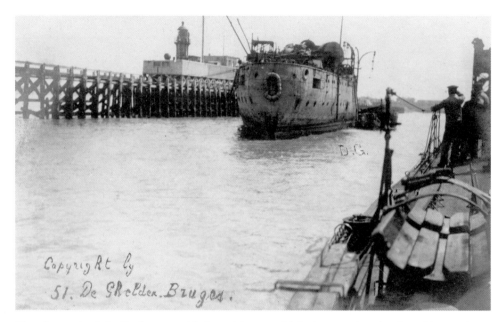

The aftermath of the Zeebrugge raid. Casualties were high; in an action that lasted just an hour and a half, 214 men, sailors and marines, were killed while over 300 were wounded. Eight Victoria Crosses were won by the attacking forces, two of them posthumously. German losses – the defending troops operating from fixed positions – were significantly lower. An assault on Ostend, involving nearly sixty vessels, took place at the same time as the Zeebrugge raid – it failed, mainly because the Germans had re-positioned several of the marker buoys and the blockships ran aground before they could reach their targets.

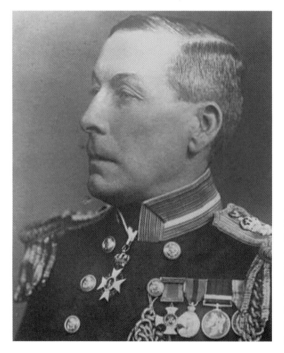

Admiral Reginald Bacon, who was in command of the Dover Patrol from 1915 onwards and a man once described by Jacky Fisher as 'the cleverest officer in the navy'. However, he apparently altered some of the original plans and dispositions for the attacks on Zeebrugge and Ostend, thus causing a degree of confusion in the minds of the attacking sailors.

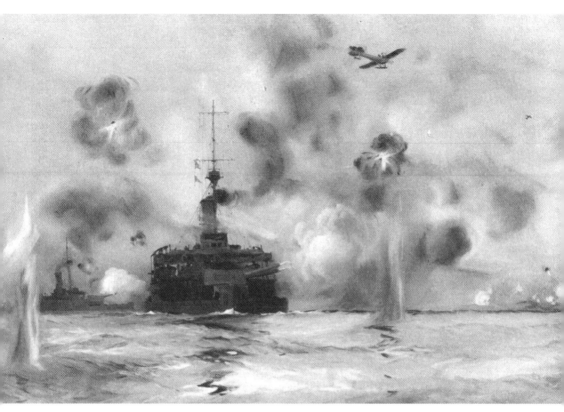

Bombardment of the Belgian coast continues. This painting shows a British monitor in action against German land batteries near Nieuport. Much-needed help for the Royal Navy.

May

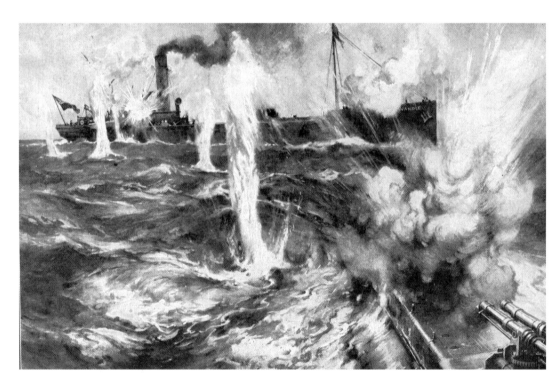

A British collier and a German U-boat are seen here engaged in a fight for survival. The submarine was hit and beat a rapid retreat while the collier made it safely to port.

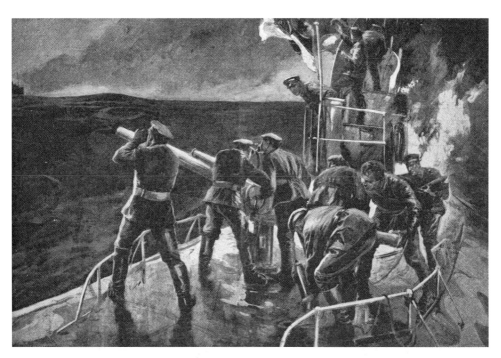

Action on the deck of a surfaced U-boat attacking a British merchant ship.

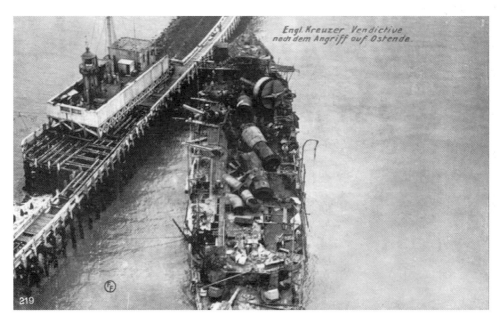

A second attack on Ostend took place on 10 May. This time the *Vindictive* – which, amazingly, had survived her battering at Zeebrugge – was to be the blockship. Once again, the old ship was subjected to heavy fire before sinking herself in the channel. Her crew were taken off by motorboats. The canal had been blocked but, after the war, it was learned that it was too shallow for submarines to use anyway.

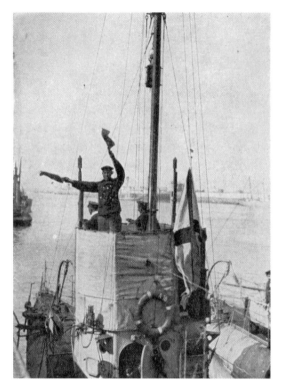

A crewman signals with semaphore from the bridge of a German torpedo boat as it leaves Ostend harbour.

A dramatic artist's impression of a German torpedo boat at the moment of launching its torpedoes at an Allied ship, Ostend harbour.

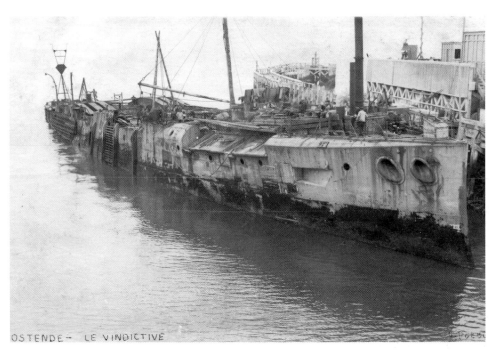

OSTENDE - LE VINDICTIVE

The shattered hull of the *Vindictive* lies at Ostend, her active service life finally over.

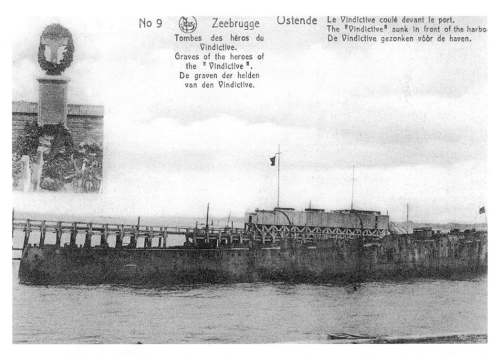

No 9 Zeebrugge Ostende

Tombes des héros du Vindictive.
Graves of the heroes of the " Vindictive ".
De graven der helden van den Vindictive.

Le Vindictive coulé devant le port.
The "Vindictive" sunk in front of the harbo
De Vindictive gezonken vóór de haven.

The cost of the raids – the graves of some of the *Vindictive* dead. The raids might have been only partially successful and were very costly in terms of loss of life, but to the public back home they symbolised the fighting spirit of the Navy. To that extent, at least, they were successful.

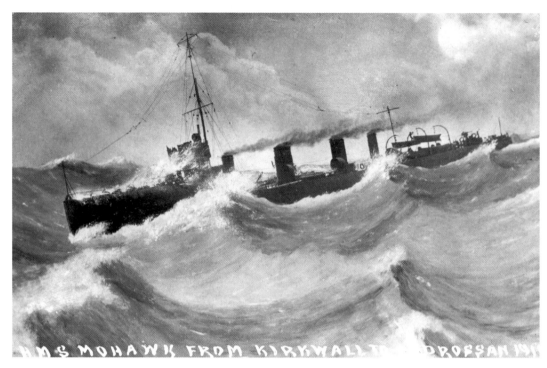

The destroyer *Mohawk* is shown here in a rough sea – heavy work for such a slight vessel.

This photograph shows the gunboat *Cicala*, which was part of the naval force operating off northern Russia. In May 1918 she was the victim of a Bolshevik mine and sank off Selso. She was later raised, repaired and used again.

Throughout the early summer of 1918, the U-boat war continued. Convoys were now hugely successful in helping merchant ships to get to Britain safely but the torpedoing of merchantmen and regular sinkings still happened, as this view shows.

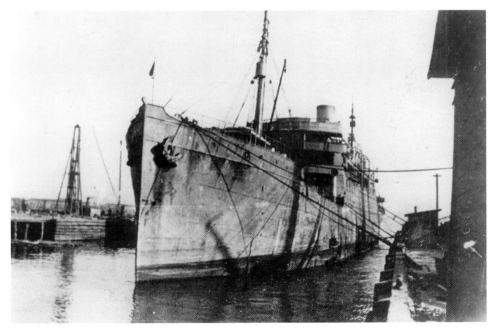

By May 1918 the US Navy – merchant and military – had become a significant factor in the way the war was being conducted. Of the 2 million American soldiers sent to France before the war ended, half were carried on American ships. This photograph shows an American troop transport tied up at the dockside.

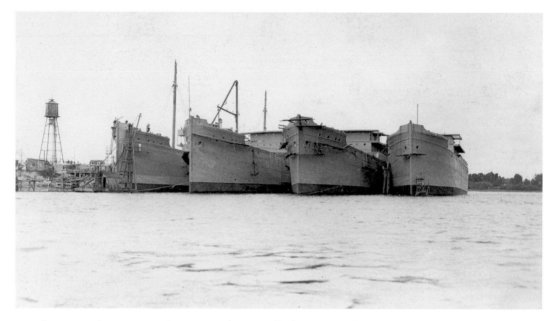

It was not just transporting men and materials that occupied American minds in 1918. The American ship building industry was soon in full flow. This shows ships nearing completion in an American dockyard.

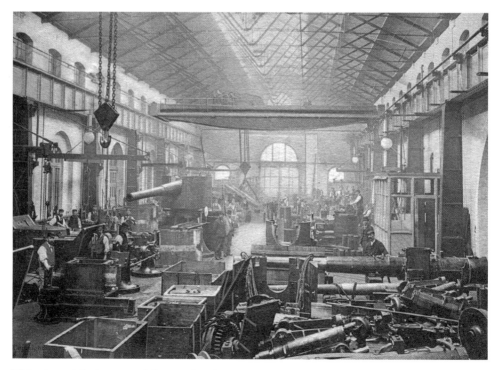

This view of the interior of the Woolwich Arsenal shows workmen fixing up the mountings for heavy guns; an unsung but vital job in war time.

June

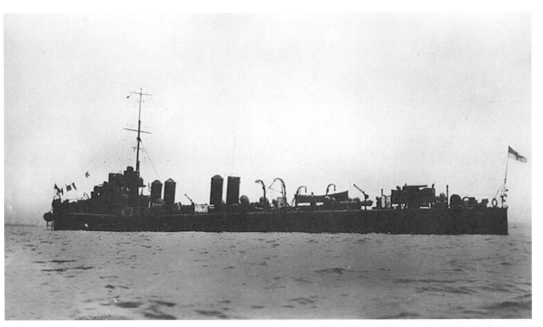

HMS *Garry*, the command of Lt Charles Lightoller, a man perhaps more famous as the senior surviving officer of the *Titanic*. As an RNR officer, Lightoller was called up for the Navy once war began and served on armed merchant cruisers before assuming his own command.

Despite losing his first ship, the *Falcon*, when she was rammed by a trawler, Lightoller went on to take over the *Garry*. He had already won the DSC but was awarded a Bar to the medal when he rammed and sank the UB110 in June.

A satirical cartoon, originally published in *Punch*, takes a decidedly anti-Russian/anti-German look at the withdrawal of Russia from the war. For the British, in particular, the Bolshevik revolution and the subsequent withdrawal from the war were nothing less than pure treachery.

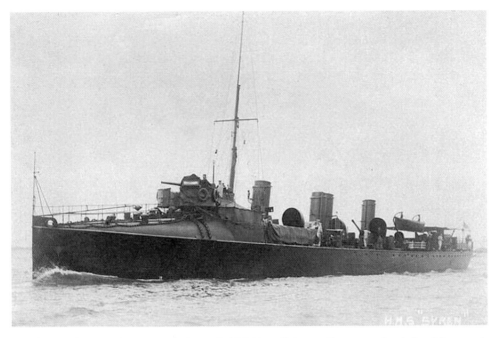

With the civil war in Russia escalating, a British Expeditionary Force was landed at Murmansk on 23 June. The destroyers *Syren* (shown here) and *Penelope* transported the small force.

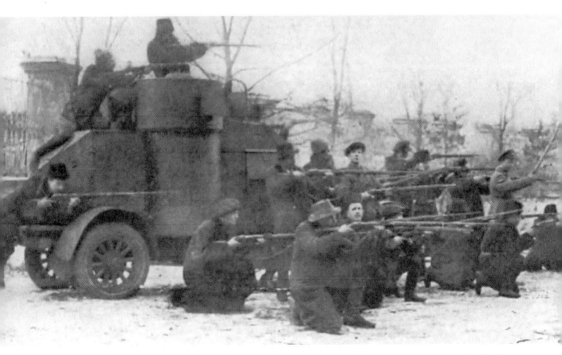

Bolshevik troops of the Red Army – marshalled and developed by Leon Trotsky – fight from the cover of an armoured car. Unlike the men of the Allied Expeditionary Force, they were fighting for their homeland and, as they saw it, for freedom from tyranny and exploitation.

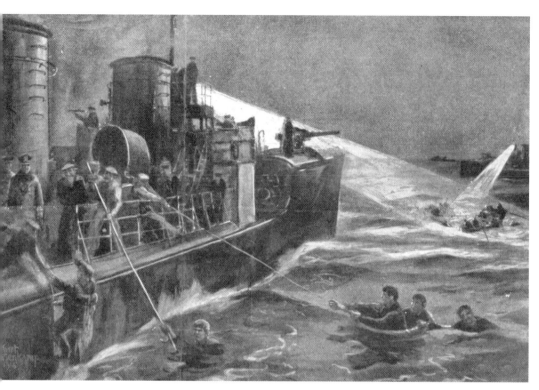

German sailors are hauled on board a British destroyer after their ship has been sunk in action. German sailors showed the same gallantry.

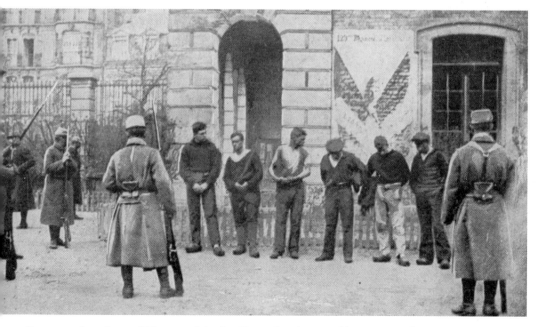

German sailors from a U-boat sunk in the Channel under guard by a group of French soldiers.

July

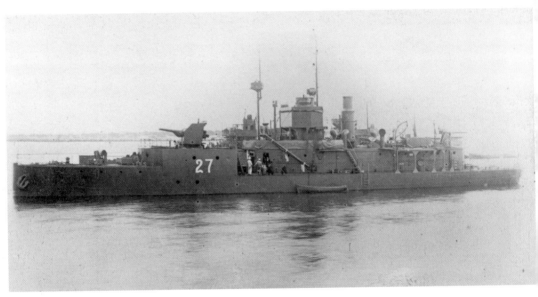

This rare photograph shows Royal Navy monitor No. 27, which served on the River Dvina in northern Russia during the war between the White and Red forces.

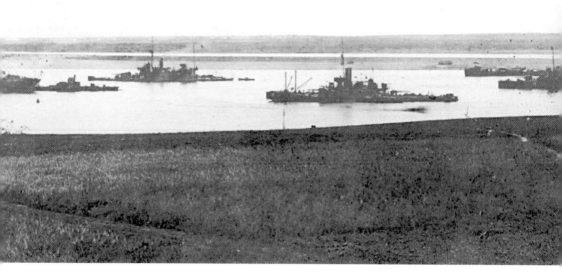

The Dvina River Flotilla is shown here, at anchor in the river, c. 1918–19. From left to right: *Hyderabad*, *Humber*, *Cicala*, a seaplane tender and the monitor M31.

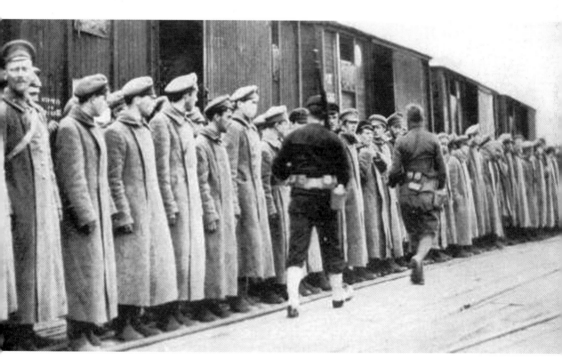

Bolshevik prisoners, taken during the fighting in north Russia, are lined up by American soldiers.

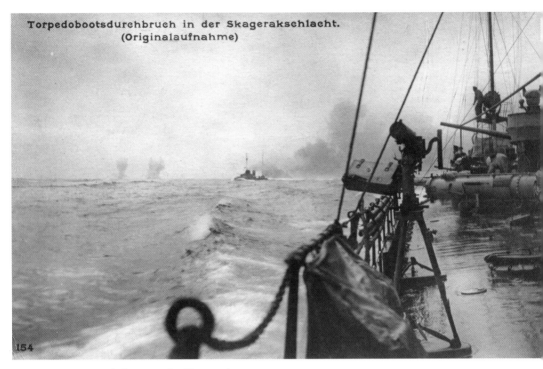

Torpedobootsdurchbruch in der Skagerakschlacht.
(Originalaufnahme)

German torpedo boats in the Skagerrak.

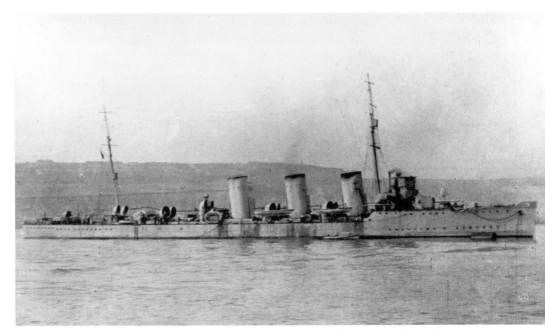

As the war progressed, destroyer development also moved on apace. The Admiralty seemed suddenly to realise the value of these small, gritty ships – and the men who sailed them. This photograph shows HMS *Swift*, one of the newer destroyers in the fleet.

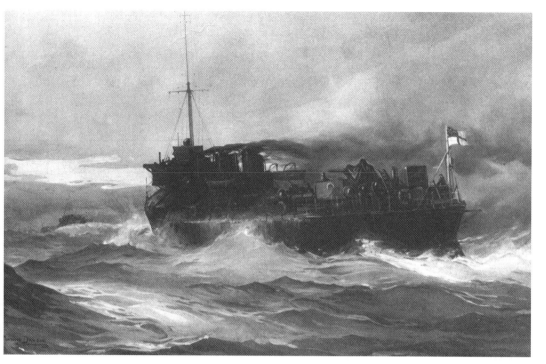

Destroyers of the Dover Patrol in action.

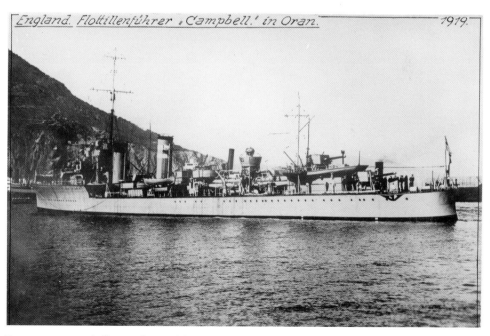

England. Flottillenführer „Campbell.' in Oran. *1919.*

Destroyers served all over the world. The destroyer *Campbell*, shown here at Oran, was just one of many globe-trotting vessels.

August

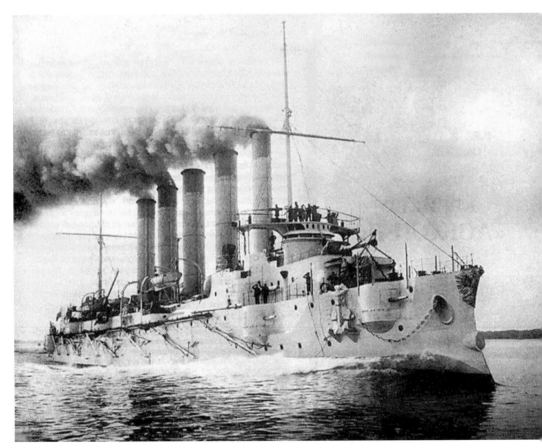

The Russian cruiser *Askold* amazed British sailors when they saw her for the first time: the Russian vessel had no fewer than five funnels. The number of funnels on a vessel was important in those days – the more funnels, the more powerful the ship, one of the reasons that the liner *Titanic* had only three working funnels and one false one. British sailors quickly gave a nickname to the *Askold* – the 'packet of Woodbines', because of her five thin funnels – Woodbine cigarettes were then sold in packets of five.

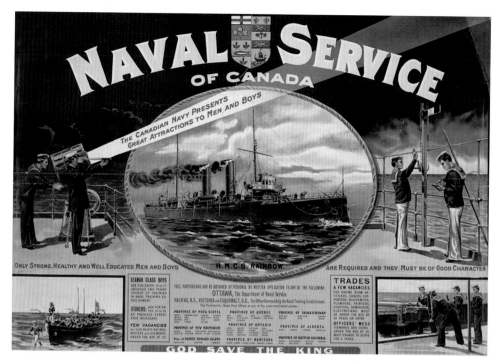

A recruitment poster for the Royal Canadian Navy that promises 'great attractions to men and boys'.

The Voyage of the Deutschland, an account of the 1916 voyages between Germany and the US by the cargo-carrying submarine *Deutschland* written by her captain, Paul König. König would be involved in running the Allied naval blockade of Germany until the end of the war.

A poster for an exhibition in Vienna that promised a 'naval spectacle'. Austria-Hungary did have a navy, although it spent much of the war penned into the Adriatic by the Italian navy.

A German poster featuring a ship running the Allied naval blockade of Germany.

The Service
for
Training
and
Travel
Ages 17 to 35

U.S. NAVY

Join the NAVY

Apply Navy Recruiting Station

Above: A recruitment poster for the US Navy, 'the Service for Training and Travel'.

Right: One way to help meet the vast financial costs of the war was to appeal to ordinary citizens for contributions. This poster asks the viewer for 5 shillings to 'crush the Germans'.

LEND YOUR
FIVE SHILLINGS
TO YOUR COUNTRY
AND

CRUSH
THE GERMANS

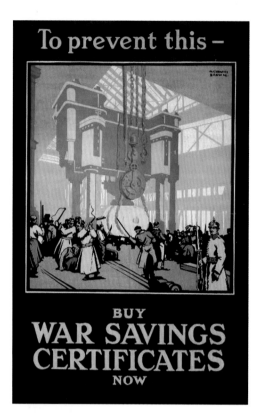

A striking and emotive poster advertising war savings certificates, another way of raising money from the civilian population for the war effort.

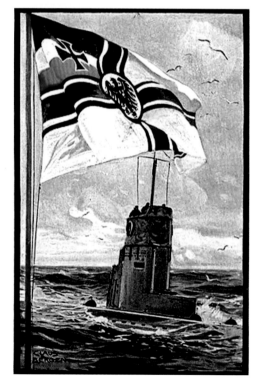

The conning tower of a U-boat rises out of the water in this German propaganda postcard, the Imperial German naval ensign flying proudly in the foreground.

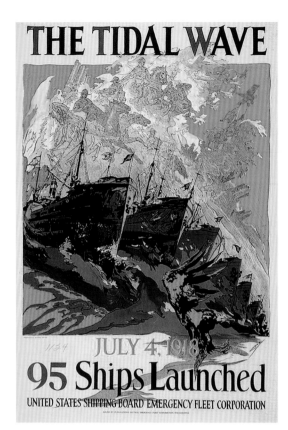

THE TIDAL WAVE

JULY 4, 1918

95 Ships Launched

UNITED STATES SHIPPING BOARD EMERGENCY FLEET CORPORATION

The 'tidal wave' of merchant shipping from US shipyards was still necessary to help beat the U-boats lurking in the North Atlantic.

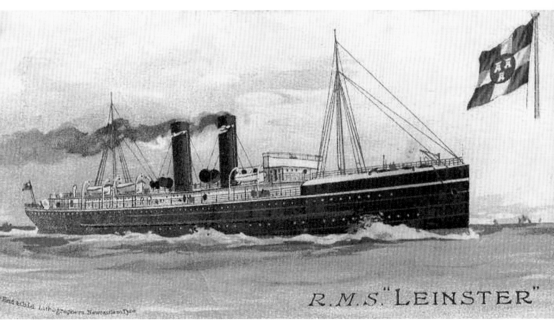

R.M.S. "LEINSTER"

A colour postcard of RMS *Leinster*, which was torpedoed in Dublin Bay on its way from Kingstown (now Dún Laoghaire) to Holyhead on 10 October.

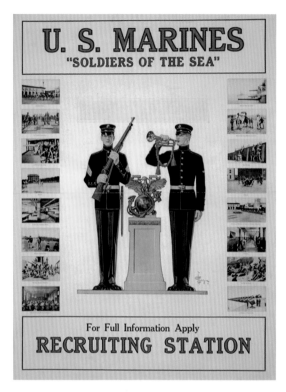

A recruiting poster for the US Marine Corps.

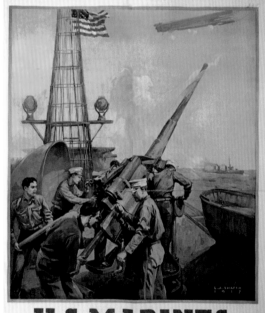

A recruiting poster for the US Marine Corps showing a gun crew firing at what appears to be a Zeppelin.

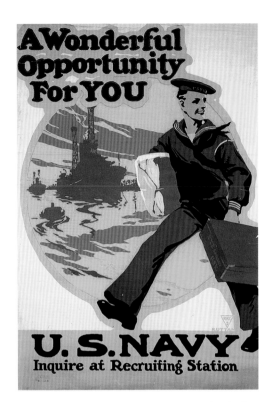

A recruiting poster for the US Navy, 'a wonderful opportunity for you'.

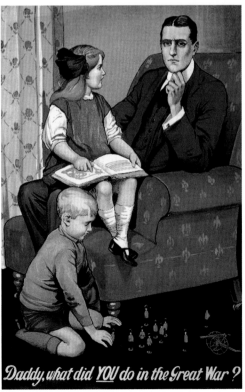

'Daddy, what did You do in the Great War?' One way to shame potential recruits into joining up.

This poster appealing for men to join the 'White Russian' forces fighting the Bolsheviks is laden with religious imagery.

The emotions of wartime died hard. Although it was in France that the desire to cripple Germany as both an economic and military power was strongest, it appeared in Britain as well, as this poster shows.

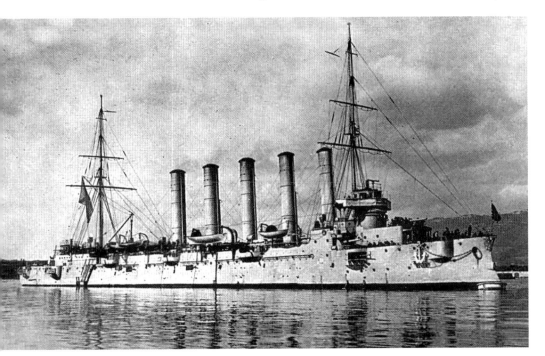

After the Russian Revolution, the crew of the *Askold* declared their loyalty to the new Provisional Government and, later, to the Bolsheviks. Her service life was short, however, as on 3 August she was captured by the British and commissioned into the Royal Navy as HMS *Glory*. She was stationed on the Gare Loch, where she was used primarily as a depot ship before being returned to the Russians and broken up in 1922.

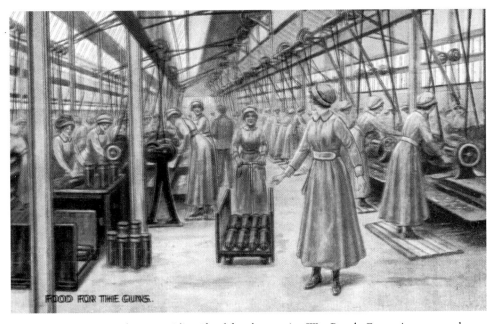

Women munitions workers providing 'food for the guns', a War Bonds Campaign postcard.

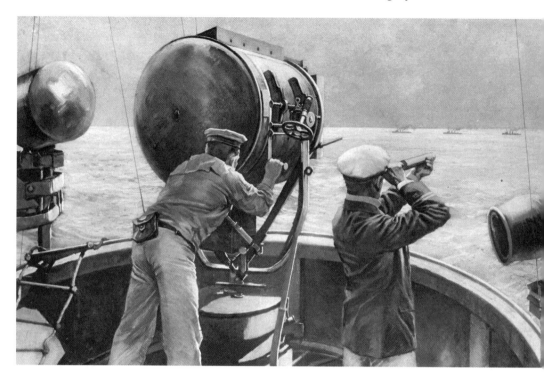

British sailors using a heliograph to pass messages from ship to ship.

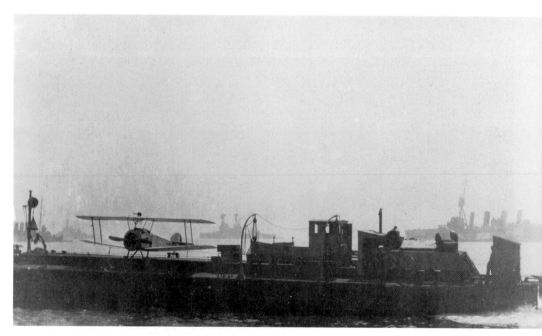

On 11 August, Lt Culley shot down and destroyed Zeppelin L53. He had taken off from a lighter that was towed by a destroyer. This shows an early Sopwith fighter precariously balanced on a barge, much as Culley's aircraft would have been.

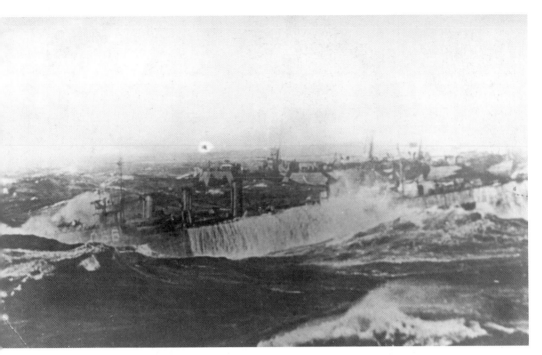

A convoy and its escort are shown here at sea in rough weather, the photograph having been taken from the deck of one of the merchant ships.

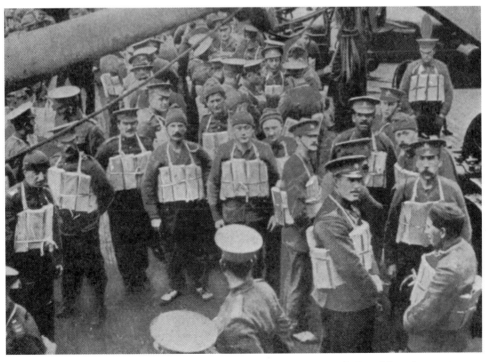

Canadian soldiers mustered on the deck of their troop transport with their life jackets on.

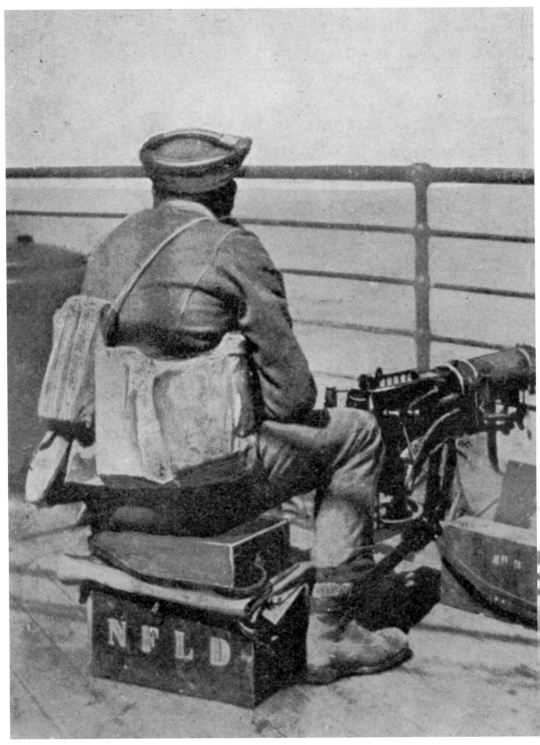

A soldier of the Newfoundland Regiment sits behind a machine gun on the deck of a transport ship, watching for U-boats.

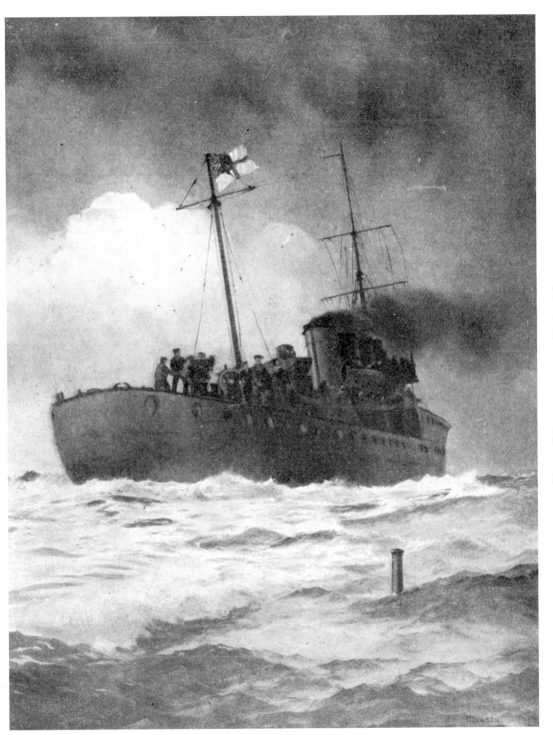

Trying to spot enemy submarines was a difficult business, as this view shows. The 'periscope' located here by sailors on the deck of the patrolling destroyer turned out to be no more than a broken and drifting spar.

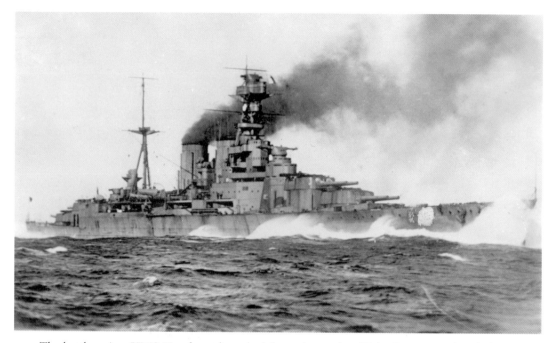

The battlecruiser HMS *Hood* was launched from the yards of John Brown on the Clyde on 22 August. Too late to have any influence on the course of the First World War, she went on to play a dramatic role in the Second.

Opposite: A postcard advertising the work of the Soldiers' and Sailors' Tobacco Fund – amazing to think that men were encouraged to smoke during the dark days of the First World War. It was, however, one of the few comforts that men on the destroyers, cruisers and battleships of the Fleet – not to mention those waiting in the trenches – could actually enjoy.

September

SAILORS' & SOLDIERS' TOBACCO FUND

IT IS A SIGNIFICANT FACT THAT ALMOST
EVERY LETTER FROM THE FRONT CONTAINS
A REQUEST FOR "SOMETHING TO SMOKE".

Contributions gratefully received by
Hon. Sec., CENTRAL HOUSE, KINGSWAY, LONDON, w.c.

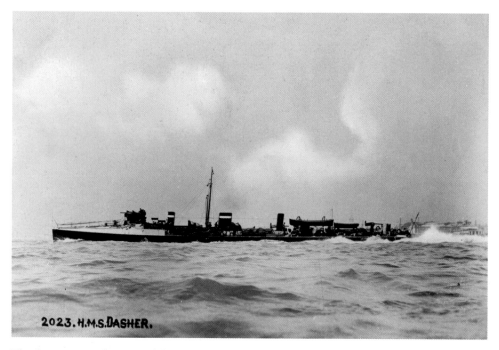

The destroyer *Dasher*, one of the many so-called 'eyes of the Fleet'.

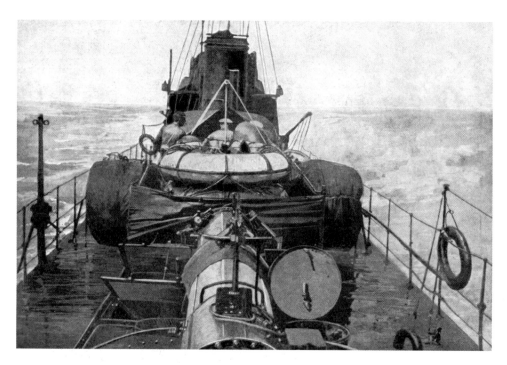

The deck of a British destroyer at speed in the Channel; good sea legs would have been required just to stay upright.

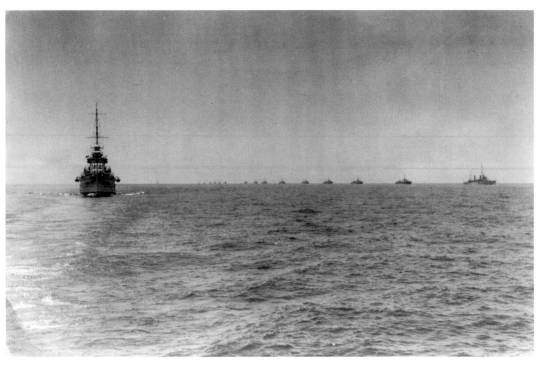

Heavily laden, a convoy heads out to sea.

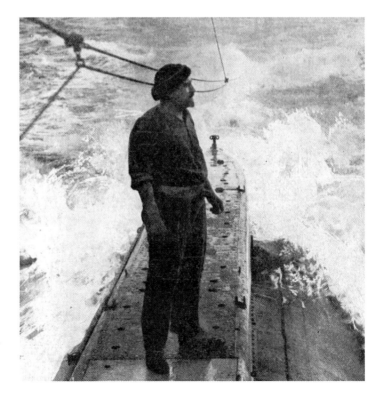

Submarines were tiny vessels. This shows a British sailor standing on the narrow deck of the submarine E4 – no room for a slip-up or loss of balance.

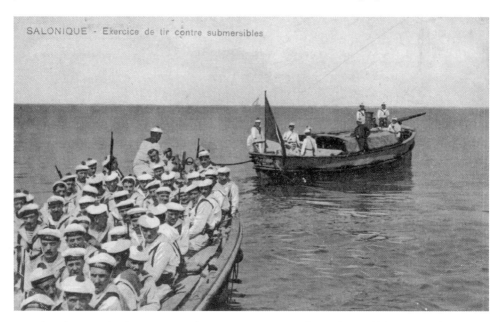

French sailors involved in an anti-submarine exercise are shown here off the coast of Salonika. Their unhappy faces show that the task is not an easy one.

A French torpedo boat on patrol off Salonika.

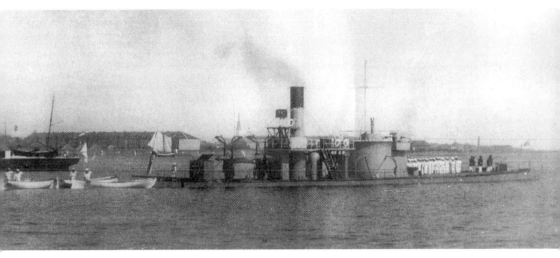

This rare photograph shows the river gunboat *Koldun*, one of many small vessels employed during British operations against the Bolsheviks around Murmansk.

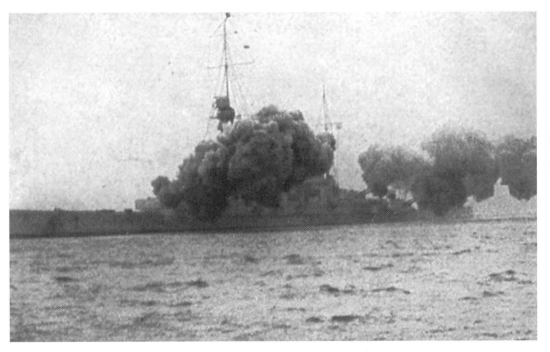

The German battlecruiser *Derfflinger* in action.

October

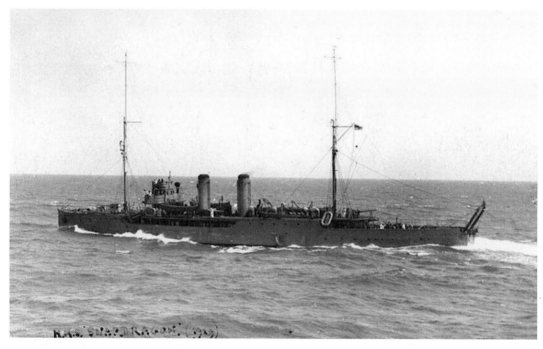

On 4 October the sloop *Snapdragon*, operating in the central Mediterranean, sank the UB68. The submarine's commander, Karl Donitz, survived the sinking and went into captivity for the last few weeks of the war, only to resurface as commander of Hitler's U-boat fleet during the second great war of the twentieth century.

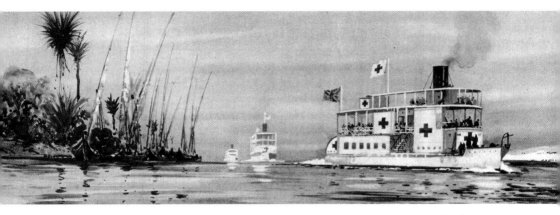

All sorts of vessels were co-opted into service during the war, even the pleasure craft of Thomas Cook, one of which is shown here operating as a hospital ship on the River Nile.

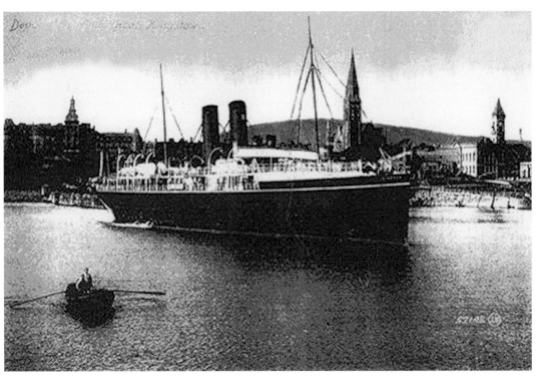

The first Wren to die on active service, Josephine Carr was one of 480 passengers and crew lost when the steam packet *Leinster* was torpedoed on 10 October. The *Leinster* was en route from Kingstown (now Dún Laoghaire) to Holyhead and went down in rough seas off Dublin Bay. This shows the *Leinster* in her pre-war days.

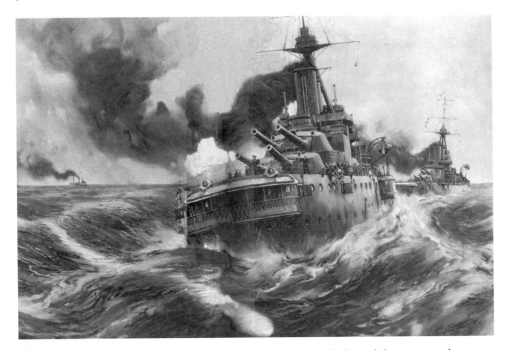

A near miss! A German torpedo passes astern of a British battleship while crew members gaze on in horror. It is a dramatic drawing but it gives a good indication of what such an event would have been like for the sailors on board.

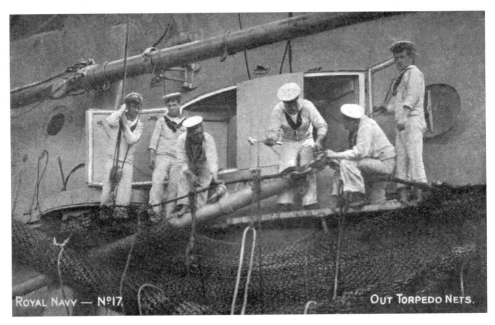

A British postcard showing sailors mounting anti-submarine nets along the side of their battleship. Anti-submarine nets were supposed to prevent torpedoes striking against the side of the ship, a tactic that was never particularly successful.

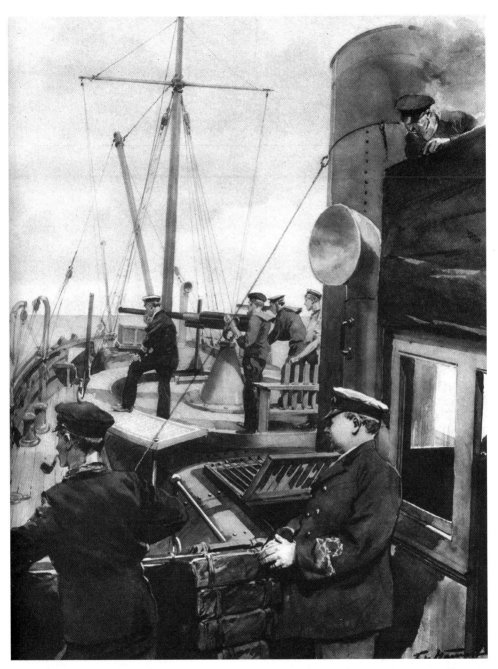

A patrol boat enforcing the British blockade of Germany.

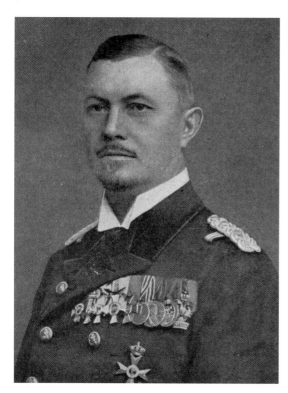

On 22 October, Admiral Scheer, the Chief of the German Admiralty Staff (above), ordered Admiral Hipper, commander of the High Seas Fleet (below), to prepare for a decisive battle with the Royal Navy in the southern North Sea. However, once the fleet had assembled off Wilhelmshaven on 29 October, the sailors mutinied, convinced their commanders were preparing to sacrifice them to sabotage the armistice negotiations that were still ongoing.

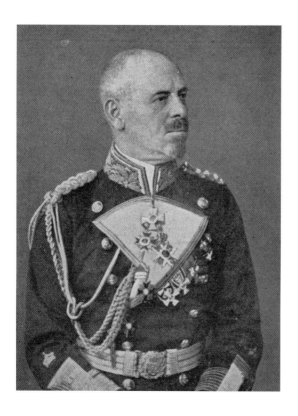

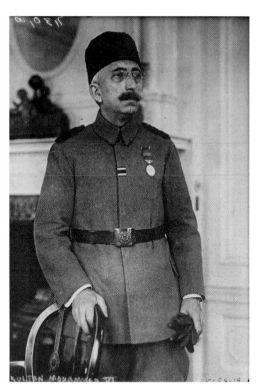

Faced with defeat, the Turkish sultan, Mehmed VI (above), dismissed Enver Pasha (below) as Minister of War on 4 October. The rest of the government resigned on 14 October. (LoC)

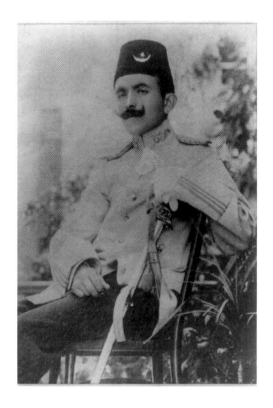

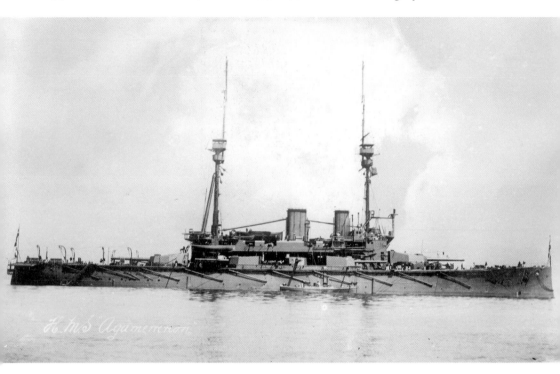

War with Turkey ended when an armistice was signed on 30 October. The document was signed as part of a formal ceremony on the deck of the battleship *Agamemnon*, an agreement that virtually ended the Turkish Empire and brought about the conclusion of fighting in one of the bloodiest theatres of the whole war.

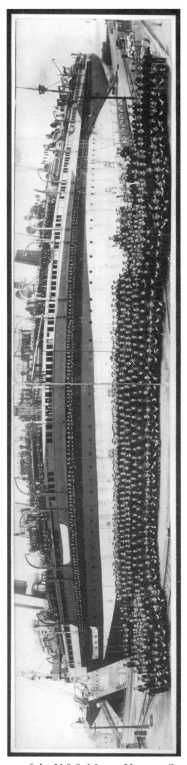

Officers and crew of the U.S.S. Mount Vernon, October 30, 1918.

November

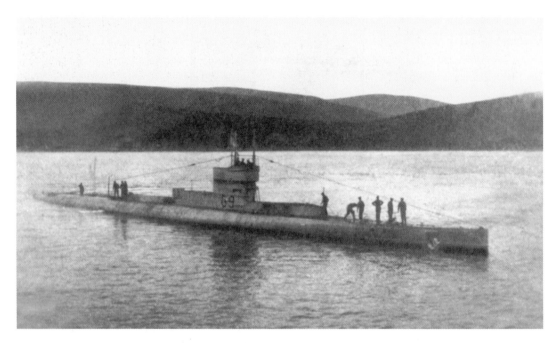

When the G7 was sunk in the North Sea on 1 November, it was the last British submarine loss of the war. This shows the G9, an identical sister ship to the ill-fated G7. Over fifty Royal Navy submarines were lost during the war.

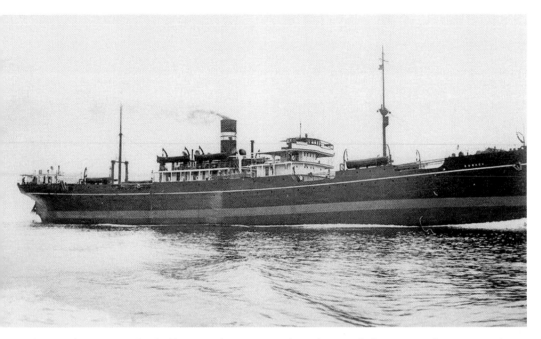

The *Surada* was torpedoed off Port Said on 2 November. Along with the *Murcia*, she was one of the last two British merchant ships lost to enemy submarine action in the war.

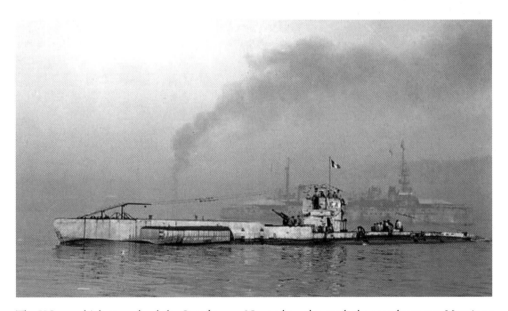

The UC74, which torpedoed the *Surada* on 2 November, also sank the merchantman *Murcia* at the same time. It was a late success for the German U-boat fleet.

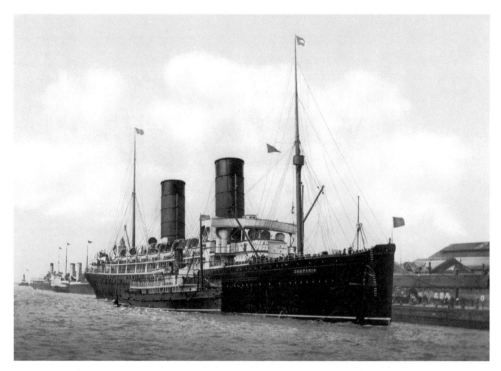

British losses continued during the final month of the war. On 5 November, the seaplane tender *Campania* was sunk in the Firth of Forth after a collision with the *Royal Oak* and the carrier *Glorious*.

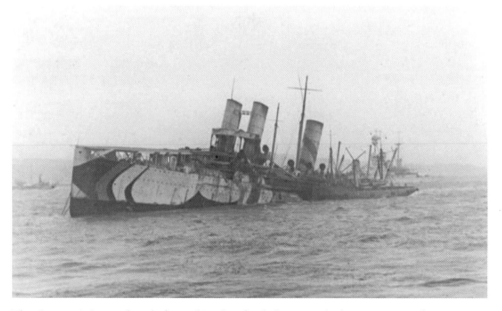

The *Campania* is seen here before taking her final plunge to the bottom. Her sinking was not down to enemy action, she had simply dragged her anchors in a storm and sank slowly with no loss of life.

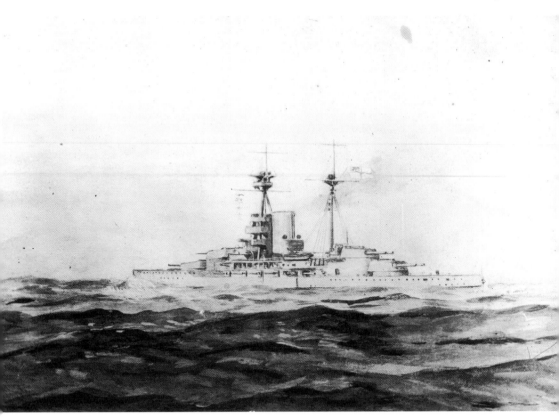

The battleship *Royal Oak*, with which *Campania* collided. (J&C McCutcheon Collection)

Next page: The *Campania* was, before the war, a Cunard liner. This shows a Passenger Log Book for her and other Cunard ships in 1894, in the quieter and balmier days long before war broke out.

The last unsuccessful U-boat attack on a British merchant ship took place on 7 November, when an attempt was made to sink the merchantman *Sarpendon*.

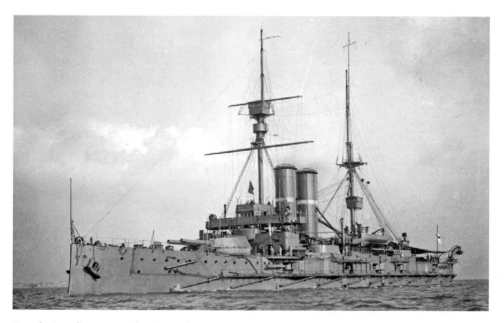

Royal Navy losses to U-boat attack continued to the end of the war. On 9 November, just two days before the Armistice was signed, the pre-Dreadnought battleship *Britannia* was torpedoed and sunk off Cape Trafalgar while she was engaged in convoy escort duties. Fifty men died in one of the final naval actions of the war.

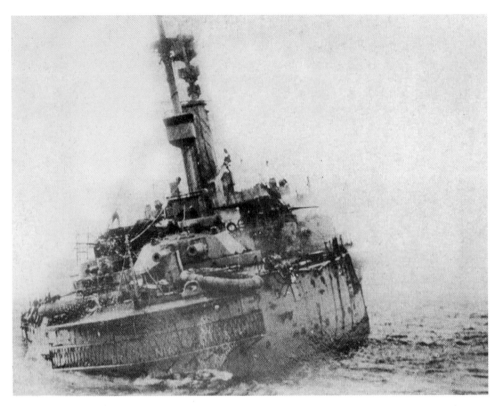

The *Britannia* takes her final plunge in the cold waters of the northern Atlantic. The tragedy of the sinking lay in the fact that the war ended just two days later.

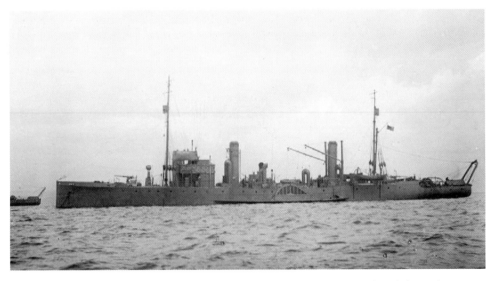

The *Britannia* was not the last Royal Navy ship to be lost in the war. That dubious honour is held by the paddle minesweeper *Ascot*, which was torpedoed by the UB67 off the Farne Islands on 10 November. The tiny vessel went down quickly, taking fifty-one of her crew with her.

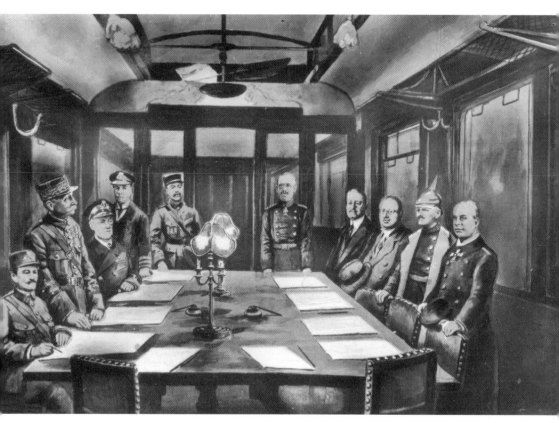

Peace at last – the Armistice is signed in the famous railway carriage in the Forest of Compiègne. Signatories for the Allies were General Weygand, Marshal Foch, Admiral Wemyss and Admiral Hope. The German delegation consisted, in the main, of politicians, the army and navy staying well clear of what they could later deride as a betrayal. The main German participant was Matthias Erzberger – he earned, not the gratitude of his countrymen, but lasting and bitter hostility.

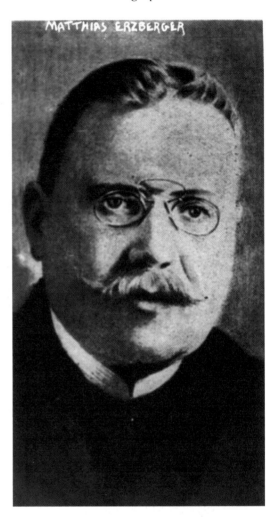

Erzberger, having signed the Armistice, would serve in the postwar German government as minister with responsibility for matters relating to the Armistice, and later as finance minister and vice-chancellor. He would be assassinated on 26 August 1921. (LoC)

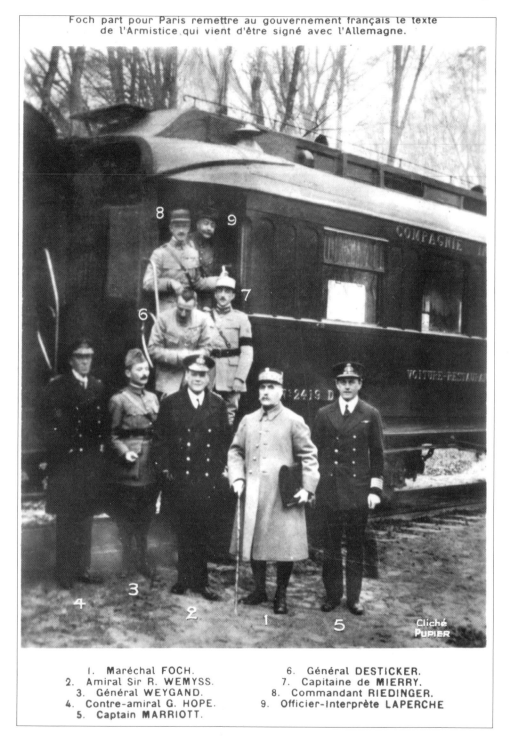

Foch part pour Paris remettre au gouvernement français le texte
de l'Armistice qui vient d'être signé avec l'Allemagne.

1. Maréchal FOCH.
2. Amiral Sir R. WEMYSS.
3. Général WEYGAND.
4. Contre-amiral G. HOPE.
5. Captain MARRIOTT.
6. Général DESTICKER.
7. Capitaine de MIERRY.
8. Commandant RIEDINGER.
9. Officier-Interprète LAPERCHE

Formalities over, the Allied representatives pose for photographs on the steps of the railway
carriage. Of the German delegation there is, perhaps understandably, no sign.

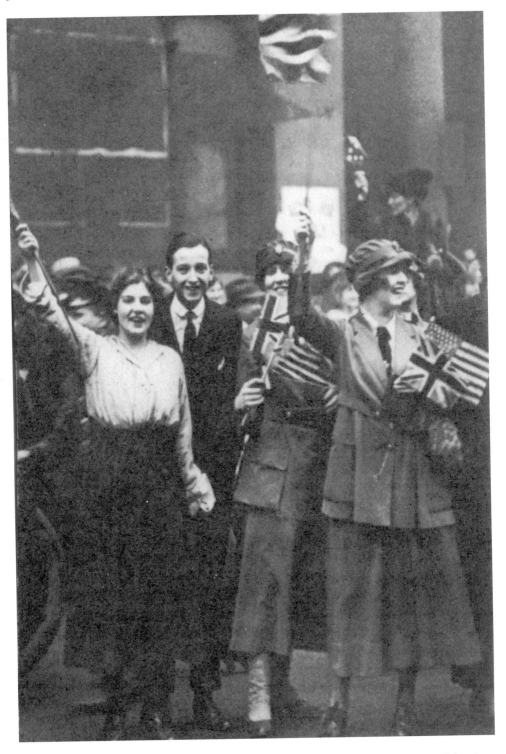

News of the peace spread rapidly and within hours of the 11.00 deadline impromptu celebrations were being held all over Britain.

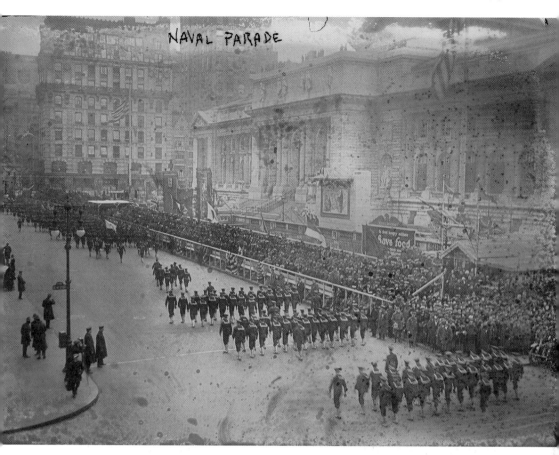

US Navy sailors parade down 5th Avenue, past the New York Public Library, to celebrate the signing of the Armistice. (LoC)

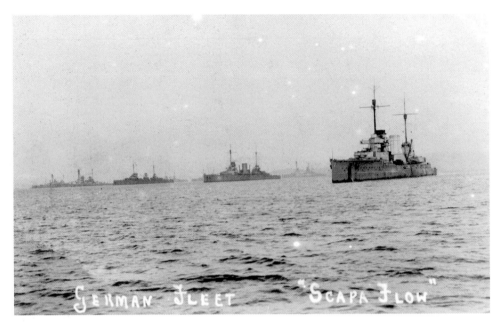

With the Armistice signed, the process of handing over the German High Seas Fleet to Britain began almost immediately. The first twenty U-boats were surrendered at Harwich eight days after the Armistice, and four days later the first battleships began to arrive at Scapa Flow. It meant that even if hostilities began again, Germany would have to fight without a navy.

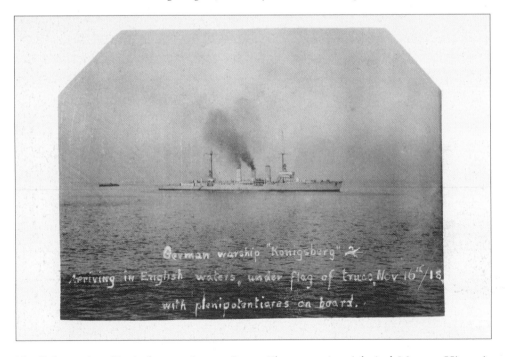

The light cruiser *Königsberg* arrives at Scapa Flow carrying Admiral Meurer, Hipper's representative, to negotiate the terms of the High Seas Fleet's surrender. (J&C McCutcheon Collection)

Admiral Meurer arrives aboard Beatty's flagship HMS *Queen Elizabeth*. Beatty, seen on the far right of the photograph, would take the opportunity to overawe and humiliate Meurer. (J&C McCutcheon Collection)

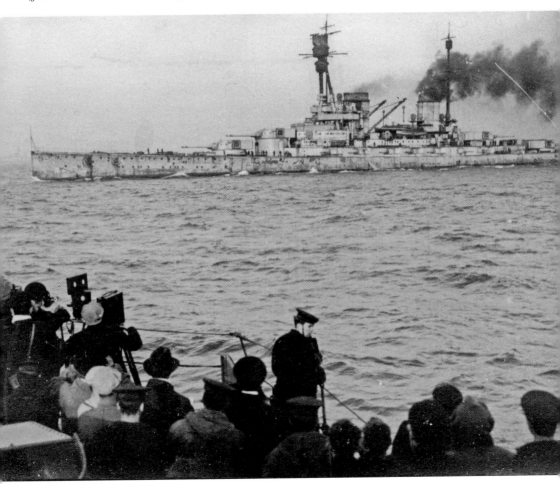

The *Königsberg* waits in Scapa Flow while Admiral Meurer meets with Beatty, watched eagerly by British sailors and journalists from a vessel nearby. (J&C McCutcheon Collection)

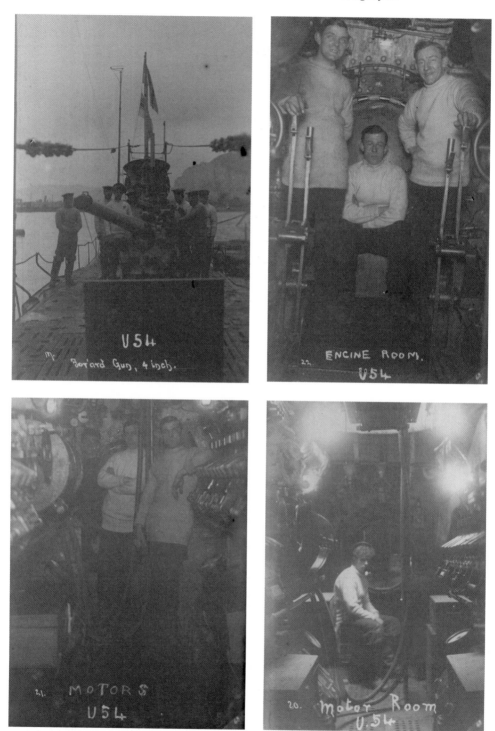

The U-boats were to be handed over first. Although most of them were surrendered to the Royal Navy at Harwich, these photographs show Royal Navy sailors examining U54, which was surrendered to the Italians at Taranto on 24 November. (J&C McCutcheon Collection)

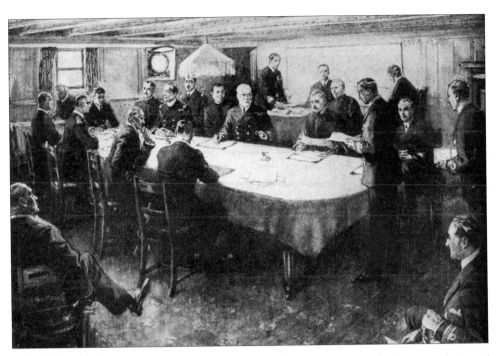

The Allied Naval Commission, meeting in the Baltic port of Kiel, ensured that the terms of surrender were complied with. (J&C McCutcheon Collection)

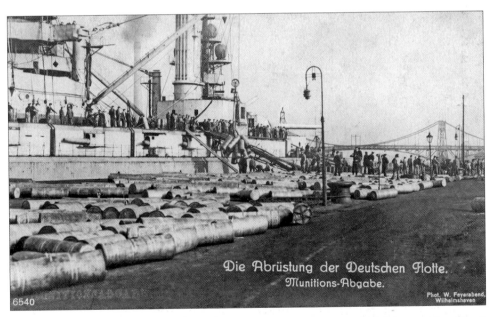

Part of the terms of surrender stated that the German ships should be disarmed, with all armaments and shells removed. This photograph, from earlier in the war, shows stores being loaded at Wilhelmshaven but the scene would have been very similar as the fleet prepared for internment. (J&C McCutcheon Collection)

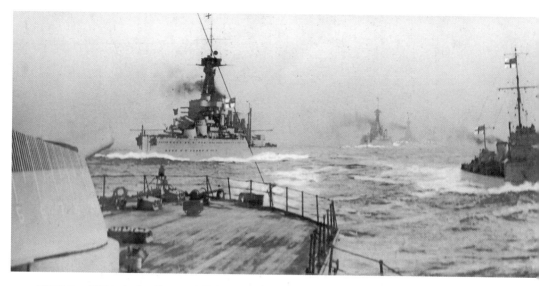

HMS *Cardiff* leads the German High Seas Fleet into the Firth of Forth on 21 November 1918, prior to internment at Scapa Flow.

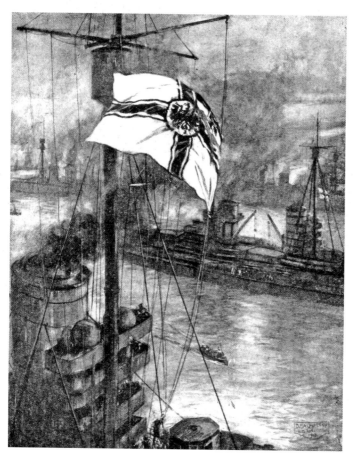

The German flag is hauled down from the mastheads of the High Seas Fleet for the last time at sunset on 21 November. Beatty ordered that it should not be flown again without permission. (J&C McCutcheon Collection)

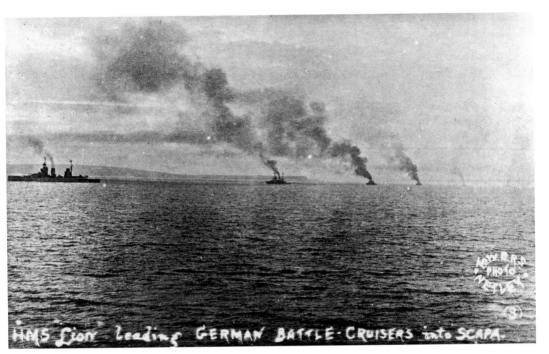

HMS *Lion* leads a group of German battlecruisers into Scapa Flow. (J&C McCutcheon Collection)

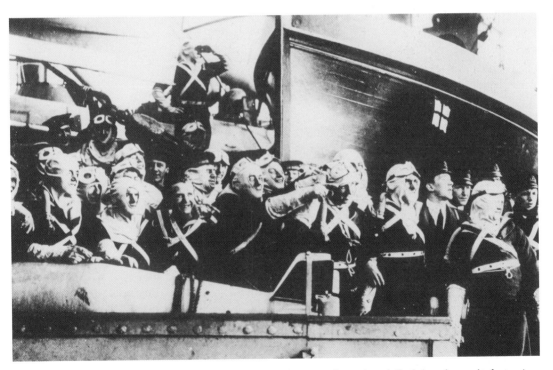

British sailors, mistrustful of the Germans and wearing gas masks and anti-flash hoods, ready for action, watch as the groups of German ships are led into Scapa Flow. (J&C McCutcheon Collection)

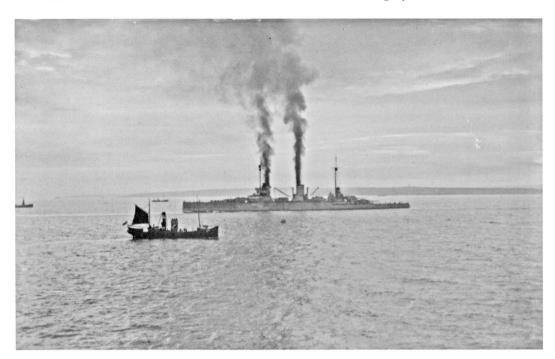

The battlecruiser SMS *Moltke*, newly arrived in Scapa Flow, with steam still up, is circled by one of the steam drifters that served the Royal Navy ships based there. (J&C McCutcheon Collection)

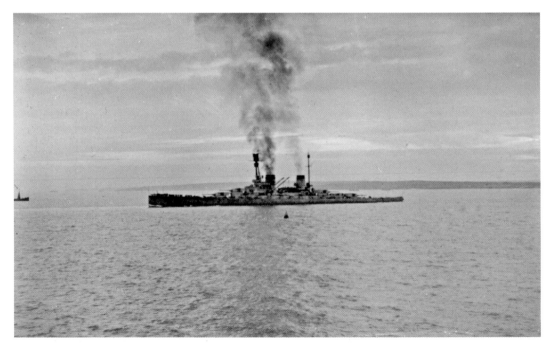

The battlecruiser *Derfflinger* also sits with steam still up after arriving in Scapa Flow. (J&C McCutcheon Collection)

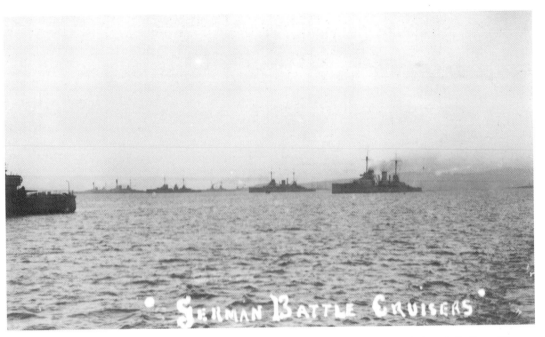

German battlecruisers, harmless now, lie at anchor in Scapa Flow. Surrendering their fleet did not come easily to the Germans but Britain, mindful of the threat posed by the German Navy, was not going to take any chances in the new post-war world. Germany would be denied any warships that might be used against the British Empire.

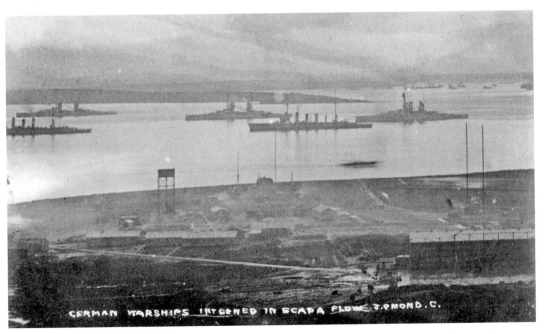

Another view of the interned German Fleet, riding easily at anchor in Scapa Flow, all of the ships with their crews still on board.

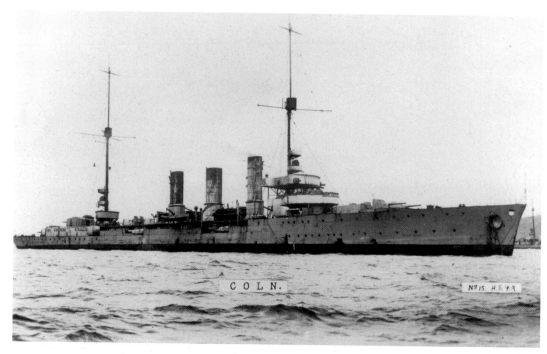

It was not just capital ships that were handed over; cruisers and destroyers also made the painful and humiliating trip across the North Sea. This shows the light cruiser *Cöln* in Scapa Flow.

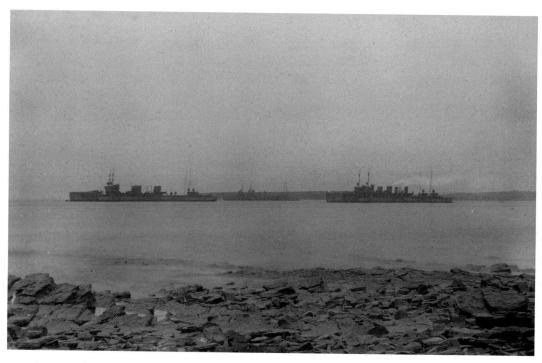

A group of German destroyers at anchor in Scapa Flow. (J&C McCutcheon Collection)

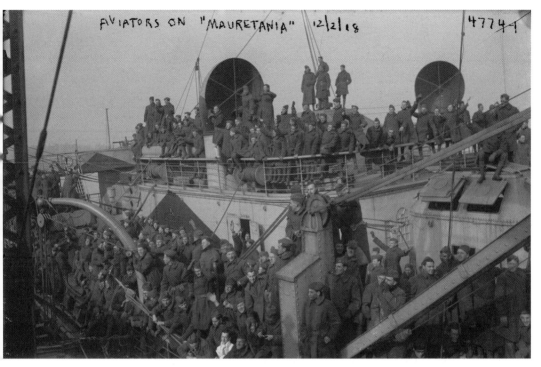

American aviators aboard the liner *Mauretania* on their way home in December 1918. (LoC)

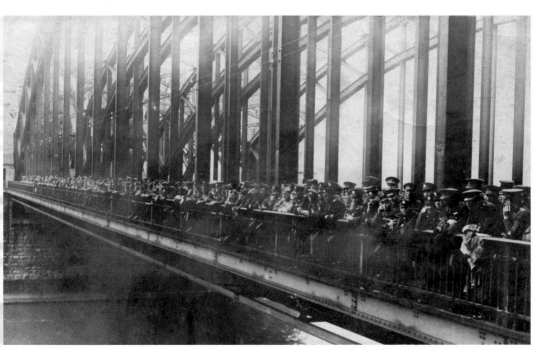

British forces occupied Cologne the month after the Armistice was signed. This shows British soldiers lining the Hohenzollern Bridge in the city.

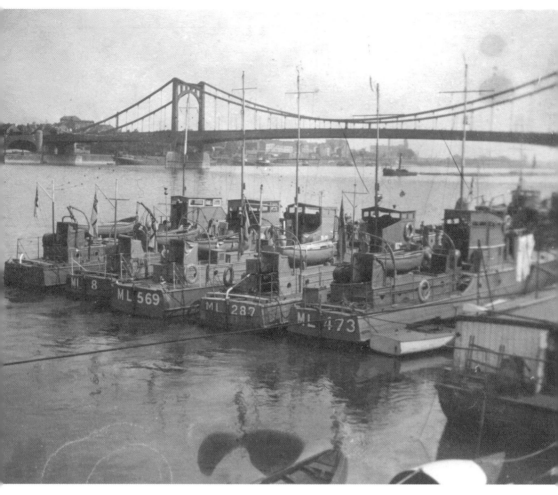

British motor boats moored at Cologne – these small, fast craft, ideal for operations on the Rhine, were an important part of the occupying force.

Postscript
1919 to 1920

If the Royal Navy thought that the war was over by November 1919, it was sadly mistaken. There were still trade routes to patrol and a powerful motor boat squadron, based at Cologne, was an important part of the army of occupation.

The interned U-boats were quickly scrapped or handed over to Allied navies but the ships of the High Seas Fleet remained at anchor in Scapa Flow – until 21 June 1919, when they were scuttled by their crews. The ships were salvaged over the next twenty years, making a fortune for the salvage firms involved.

The Navy still had one more job to do. The idea of an 'unknown soldier' was first conceived by the Revd David Railton, an Army chaplain, in 1916. However, it was only in the autumn of 1920 that the Dean of Westminster agreed to the burial of an unidentified British soldier in Westminster Abbey.

With a casket made from trees in the grounds of Hampton Court Palace, the body was brought to Boulogne on 8 November 1920. Marshal Foch was in attendance and saluted the coffin as it arrived. Nobody knew the identity of the body.

With full military honours and a call normally used only for admirals, the coffin was piped aboard the destroyer HMS *Verdun*. Then, escorted by six capital ships, the destroyer brought the body of the Unknown Soldier across the Channel to Britain.

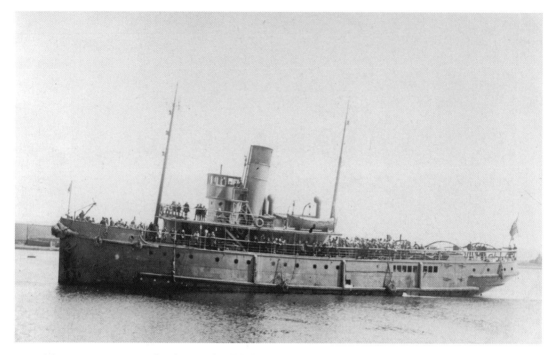

On 21 June, a group of Orkney schoolchildren were taken for a Sunday School outing around the fleet in Scapa Flow aboard the *Flying Kestrel*. They would have a grandstand view as at about noon, the German ships began to sink, the forbidden Imperial German Ensign flying from their masts. Their crews had opened the seacocks and flood valves around 11.20 that morning. (J&C McCutcheon Collection)

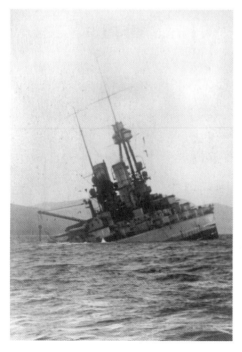

The battleship *Bayern* takes her final plunge in Scapa Flow.

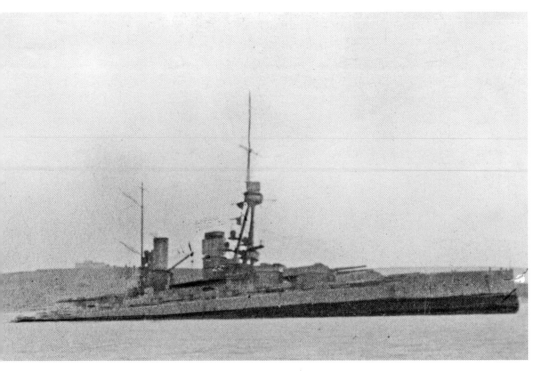

Settling quietly by the stern, another German warship slips slowly below the waves.

Sailors from the scuttled German ships are brought ashore at Scapa Flow. The British might have abhorred their actions, but to the Germans it was the only way they could end their enforced exile in a foreign country and still retain a degree of honour.

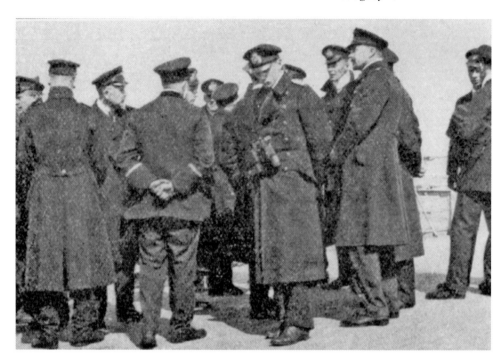

German officers from the scuttled ships aboard the battleship HMS *Ramilles*. The German commander, Admiral von Reuter, and a number of his officers would be taken aboard HMS *Revenge* to be harangued on the quarterdeck by Admiral Fremantle. The Germans listened, expressionless. (J&C McCutcheon Collection)

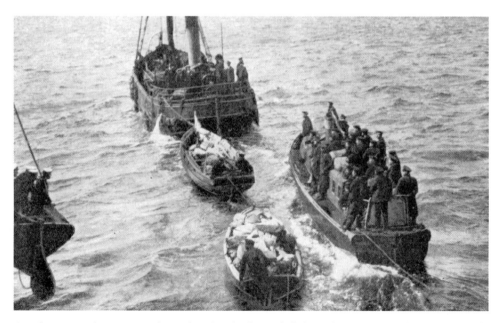

Another view of German sailors after they had scuttled their ships – now, at least, they could confidently expect to be sent home.

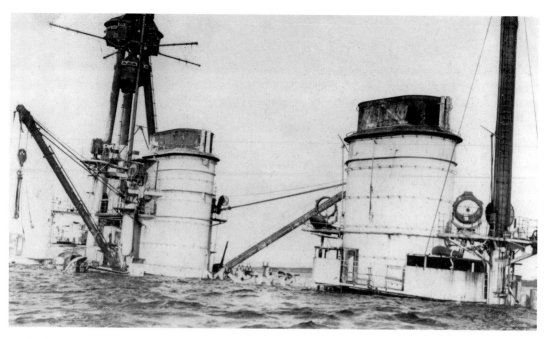

The sunken *Hindenberg* in Scapa Flow.

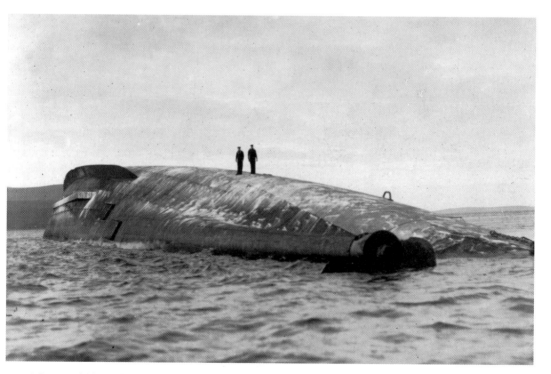

The scuttled *Seydlitz* is shown here, capsized in shallow water at Scapa Flow. Two sailors are standing on the upturned hull, the most unusual view they could ever have expected of the German warship.

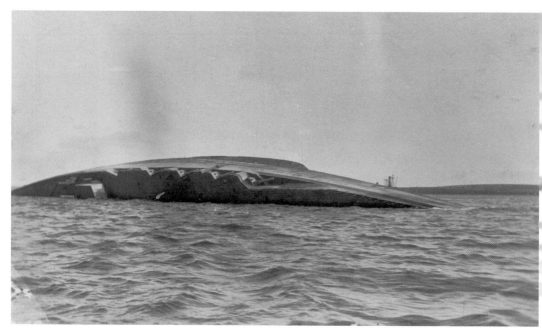

A view of the capsized *Seydlitz* from the other side, showing her deck and gun turrets. (J&C McCutcheon Collection)

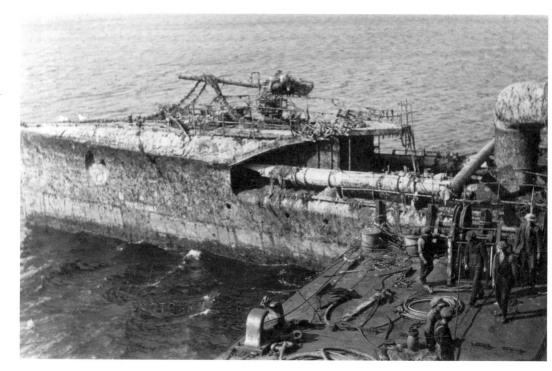

Salvaging the sunken vessels began shortly after they were sunk. This shows one of the German destroyers being hauled to the surface after just six months resting on the bottom.

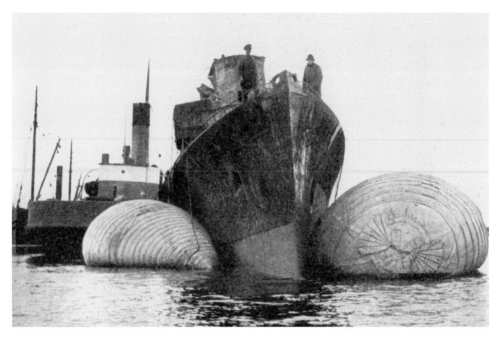

An early salvage method being tried out on the sunken German fleet. There was never any plan to re-use the sunken ships; their value now lay simply in salvage and scrap metal.

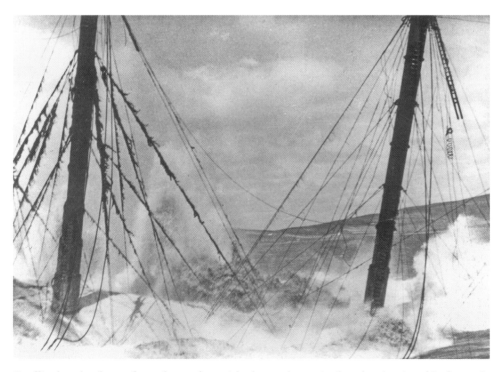

Seydlitz breaks the surface, the 60-foot airlocks used to raise her dominating this dramatic photograph. (J&C McCutcheon Collection)

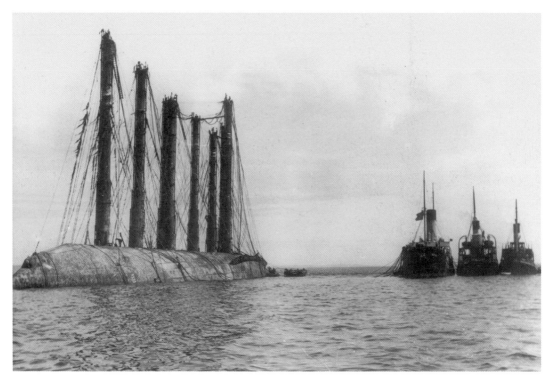

Salvaging the *Seydlitz*, two Scapa tugs in attendance.

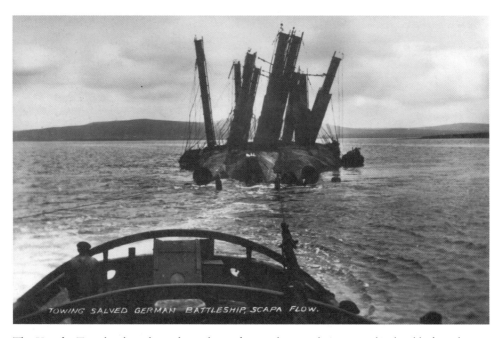

The *Von der Tann* has been brought to the surface and is now being towed to land before she can be cut up for scrap metal.

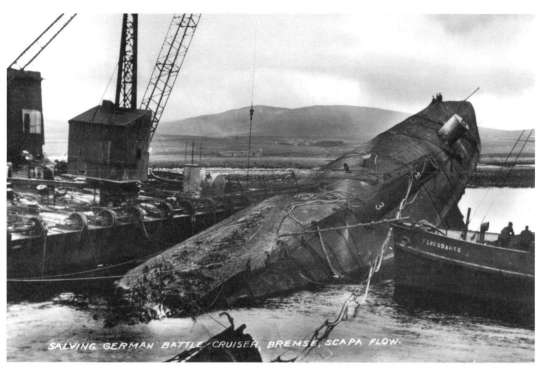

Salvaging the *Bremse*, a sad end for such a fine warship.

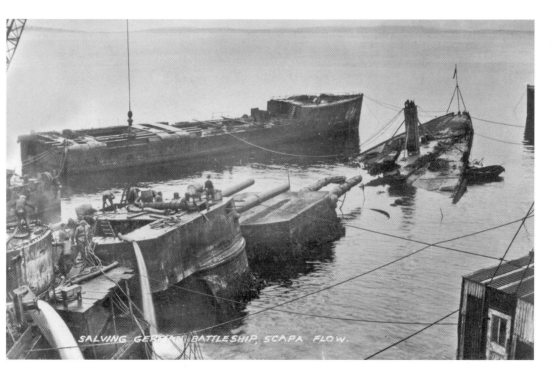

More salvage work in Scapa Flow!

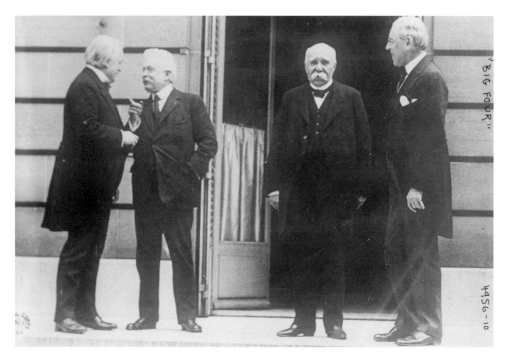

The Big Four at the Paris peace conference. From left to right: David Lloyd George; Vittorio Orlando, Prime Minister of Italy; Georges Clemenceau, Prime Minister of France; President Woodrow Wilson. (LoC)

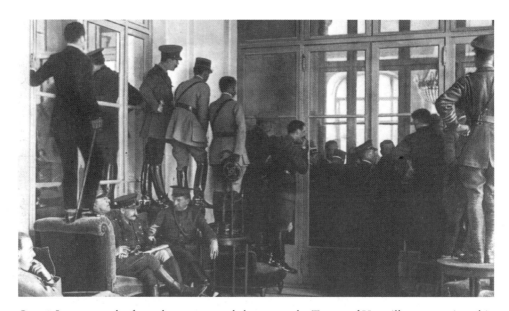

On 28 June 1919 the formal treaty to end the war – the Treaty of Versailles – was signed in the Palace of Versailles. Here, British and French officers stand on tables and chairs to get a glimpse of the great statesmen – Lloyd George, Woodrow Wilson and the rest – signing the official document.

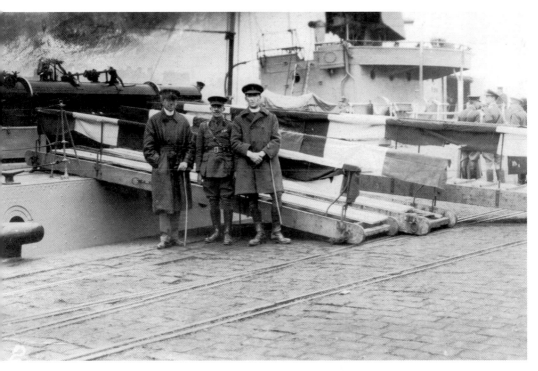

The destroyer *Verdun* takes on board the coffin of the Unknown Soldier, ready to transport the body back home.

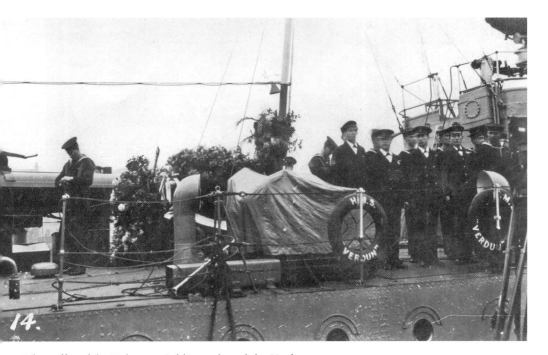

The coffin of the Unknown Soldier on board the *Verdun*.

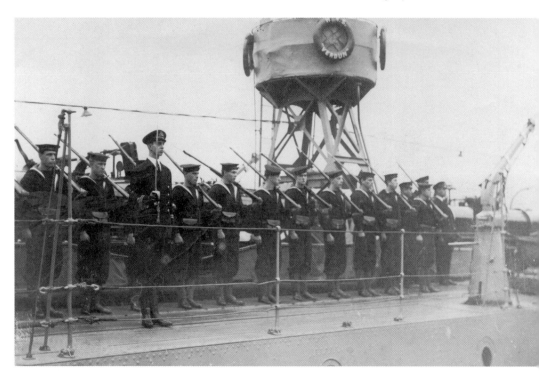

Sailors stand to attention beside the coffin of the Unknown Soldier as the *Verdun* prepares to set sail. It was the Navy's last act in the Great War.

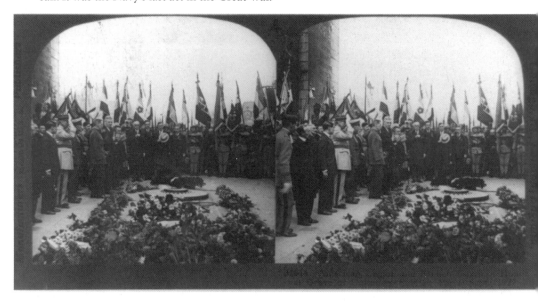

American Legion and French Guard of Honour stand at the grave of the French Unknown Soldier in Paris.

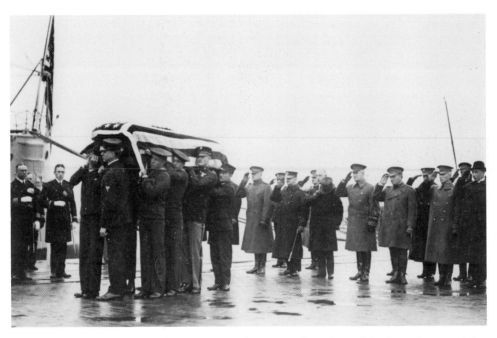

America's highest dignitaries of state, army and navy stand at salute while the casket containing the body of the unknown soldiers is borne to the casson taking it from the Navy Yard to the Capitol. In the group are General Pershing, General Lejeune, commander of the Marine Corps, General Harbord and others.

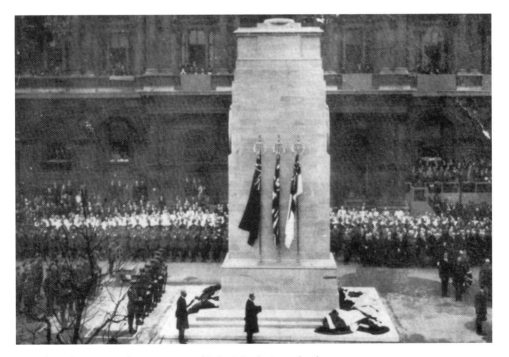

Unveiling the Cenotaph in memory of Britain's glorious dead.

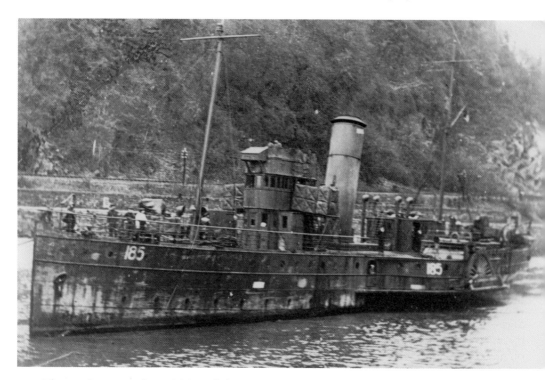

The war is over and requisitioned ships can now return to peacetime duties. This shows the paddle steamer *Glen Avon* returning to her base on the River Severn at Bristol.

Afterword

When peace came to the world in November 1918, sailors and ship owners could be excused for thinking that things would soon return to normal. Nothing could be further from the truth.

The Royal Navy soon began to suffer a series of crippling cuts, particularly in the area of the small escort vessels that had played such a vital role in defeating the U-boat menace. With Germany beaten and forbidden to build any submarines there was, planners felt, no need to maintain such a high proportion of sloops and destroyers. It was a tragic and costly mistake that nearly resulted in disaster when war began again in 1939 and Britain found herself with virtually no suitable vessels to protect the convoys against a new hoard of German U-boats.

The huge battle fleets would remain, albeit cut back or pared down, and there would be little in the way of new capital ship construction. Adherence to the Naval Armaments Treaties of the post-war years seemed more important than monitoring what was going on in Nazi Germany, where Hitler and his cronies were rapidly producing pocket battleships to avoid treaty regulations and then, as the march towards conflict began to seriously speed up, laying down massive warships like the *Scharnhorst*, *Bismarck* and *Tirpitz*.

To begin with, in the immediate post-war years there was something of a resurgence in the merchant shipping industry as ship owners began to replace lost vessels and men started to return from the war. A port like Cardiff – which had an almost total reliance on the coal trade – was soon able to boast 122 shipping companies, making it the largest port in the world.

However, as the 1920s unfolded and as economic hardships began to bite, many of the new or resurgent shipping companies folded. Ships were laid up and seamen soon found themselves out of work. The slump in shipping was world-wide but single-trade ports like the South Wales docks at Cardiff, Barry and Penarth suffered most.

Coal, in the post-war years, was suddenly available at the cheapest of rates from many new sources – Poland, South America and, not least, as part of the reparation payments that Germany had been forced to make as part of the Treaty of Versailles. Shipping declined until it reached the stage where it would take another world war to give it another new fillip.

The First World War had been fought, according to Lloyd George and the other politicians, to create a country worth returning to – to the men of Britain's merchant fleet in the hungry twenties and thirties, that dream seemed a very long way away.

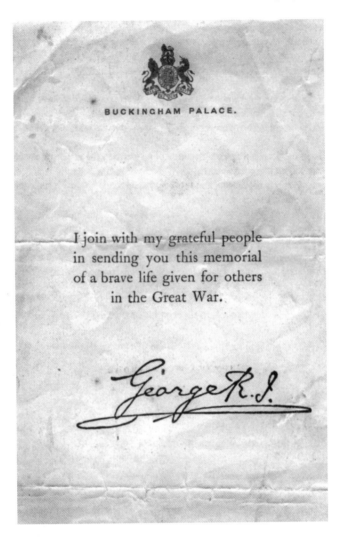

With the war over it was time to take stock. This message from the king was received by everyone who had lost a partner, son or daughter in the war.

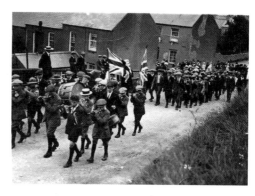

Victory parades were held right across Britain. This photograph shows the parade in Pembroke Dock, a naval and dockyard town which had lost seven ships in the conflict.

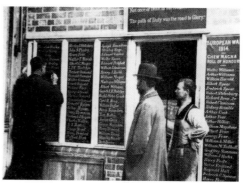

Commemorating the dead began with the creation of Rolls of Honour in communities across the country. This had been a war which affected everyone and the desire to commemorate the dead was strong.

In the first half dozen years after the war, memorials sprang up in every town that had lost soldiers and sailors.

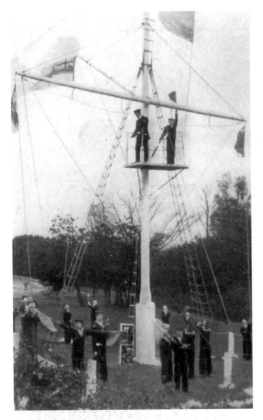

In Penarth, South Wales, a much more practical memorial was created when the Gibbs shipping family donated an old hotel and its grounds to the National Children's Homes and Orphanages. The hotel was to be converted into a nautical training school where the orphans of men killed in the war were to be trained in seamanship.

Known as the J. A. Gibbs Home (in memory of Major James Angel Gibbs), the home opened in 1918. This photograph shows trainees using HMS Mal der Mer, an ingenious device to teach young boys how to steer a ship at sea without failing victim of seasickness.

An inspection of the Gibbs home by the future king in 1921.

Top: Despite cutbacks, the Royal Navy continued to train men and boys. This photograph shows two of the training ships, one old one new, used to carry out this training.

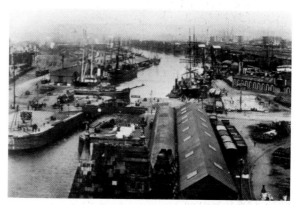

Middle: Cardiff Docks, shown here in the brief period of prosperity in the immediate post-war years.

Below:
If the war had shown anything, it was the value of aircraft as an offensive weapon. In the years to come giant aeroplanes like the Short Sunderland would become increasingly important in naval warfare.

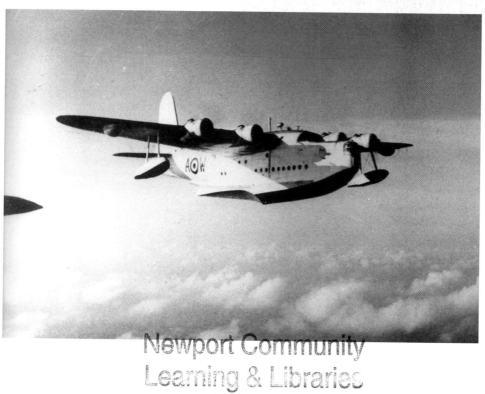

Acknowledgements

Thanks are due to many people, some no longer with us, who contributed in one way or another to the creation of this book:

To begin with my grandfather, Robert Turnbull Carradice, who told me the story of the German ships in Scapa Flow – many years ago now, but the memory is still vivid.

Trudy Carradice, who provided several of the images.

The sailors who fought and travelled the oceans of the world between 1914 and 1918.

Campbell McCutcheon, who willingly loaned photographs of the interned German Fleet and the rescue operations to bring them back to the surface.

Most of the photographs in this book are from my own collection but some have been supplied by the US Library of Congress – a marvellous resource for any researcher.

Staff at the Central Library in Cardiff.

Also available from Amberley Publishing

THE FIRST WORLD WAR AT SEA
IN PHOTOGRAPHS

1914

PHIL CARRADICE

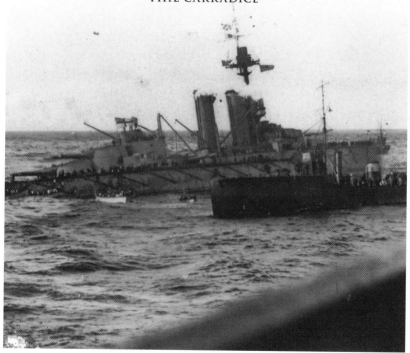

Available from all good bookshops or to order direct
Please call 01453-847-800
www.amberleybooks.com

THE FIRST WORLD WAR AT SEA
IN PHOTOGRAPHS

1915

PHIL CARRADICE